LEE BANK TO ATTWOOD GREEN

THROUGH TIME

Ted Rudge & Keith Clenton

AMBERLEY PUBLISHING

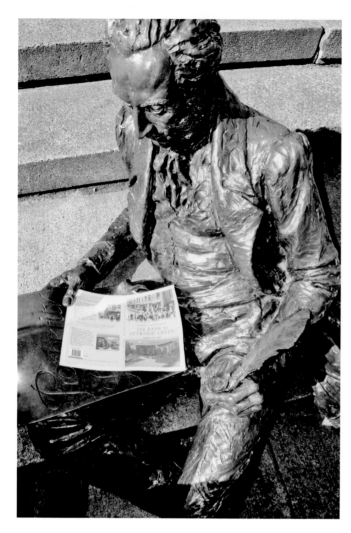

Thomas Attwood
Bronze statue of Thomas
Attwood on the steps
in Chamberlain Square,
Birmingham.

First published 2010

Amberley Publishing
Cirencester Road, Chalford,
Stroud, Gloucestershire, GL6 8PE

www.amberley-books.com

Copyright © Ted Rudge and Keith Clenton, 2010

The right of Ted Rudge and Keith Clenton to be
identified as the Authors of this work has been
asserted in accordance with the Copyrights, Designs
and Patents Act 1988.

ISBN 978 1 4456 0211 0

British Library Cataloguing in Publication Data.
A catalogue record for this book is available from
the British Library.

Typeset in 9.5pt on 12pt Celeste.
Typesetting by Amberley Publishing.
Printed in the UK.

Foreword

Because it had no name of its own for so long, the Lee Bank neighbourhood has suffered from inattention. Always part of the manor of Birmingham, it has sometimes been seen incorrectly as part of Edgbaston. Even the post-war planners were unsure as to what to call the district. At first it was scheduled under Bath Row, and eventually it was named Lee Bank after one of its roads. Having emerged in the nineteenth century and been cleared and refashioned in the mid-twentieth century, Lee Bank once more went through the throes of change and its name was changed again – this time to Attwood Green.

Throughout the eighteenth and nineteenth centuries, Lee Bank was known as Holloway Head – after the hill across which ran a hollow way. This was a road which had become lower than its surroundings because of the traffic which traversed it. Before Bristol Street was cut, the route over Holloway Head was actually that to Bristol and the south west accordingly, the bottom of Holloway Head was known as Exeter Row.

North of the road lay Mansells' Farm. In 1717 this was bought from the Middlemores by Harry Gough of Perry Hall. An advertisement of 1764 offered some of this land for sale – that section opposite Exeter Row. However, it was still shown as fields on Hanson's Map of 1781 – although thirteen years later on Pye's map it had been partly cut through with streets from Navigation Street in the north to Gough Street in the south. The western boundary of this neighbourhood was an unnamed road which would become Ellis Street and the focus of one of Birmingham's two Jewish Quarters. By the mid-1820s, Gough Street had reached Marshall Street, beyond which were small gardens up to the Islington Estate. These disappeared in the 1840s following the building of the Queen's Hospital and the cutting of new streets.

South of Holloway Head, gardens were laid out in 1764, but within fourteen years Windmill Street and Bow Street were apparent on Hanson's Map – and buildings were also obvious along Brick Kiln Lane, later the Horsefair. In 1781, the mapmaker drew another plan of the town and showed the windmill itself, standing close to where Florence Street would be cut. Further development was slow, and the district remained an attractive one outside Birmingham. Indeed, in 1813 an advertisement offered the lease of a pleasant house with a good garden, orchard and soft water near to the Windmill, Exeter Row.

By the late 1830s, the winding Bellbarn Road had come into view as had Ryland Road and Spring Street. A new road to Smithfield Market was also shown on Bradshaw's map of 1840. Running from Islington Row, its bottom end led across Bristol Street to Bromsgrove Street and hence to Smithfield Market. Then unnamed, it became Great Colmore Street, recalling the Colmores who owned the district. Within a decade it had offshoots such as Cregoe Street, remembering the family which inherited the property of the Colmores.

Like nearby Ladywood, the Holloway Head neighbourhood was filled with back-to-backs and like each working-class district of Brum, it was packed with hard-collaring folk. Their homes were knocked down after the Second World War and high-rise flats and maisonettes arose in

their place. Today, new developments have once more transformed Lee Bank and whatever the district has been called, its people deserve to be highlighted.

Ted and Keith's efforts with this book and as local historians are ensuring that Lea Bank is brought to the fore again as one of the old working-class heartlands of the city and that the new Attwood Green and the people from both can take their place proudly as belonging to an important and historic area.

Professor Carl Chinn MBE

Introduction

Most Birmingham people today would have known of the district on the edge of the city centre called Lee Bank but before the nineteenth century this neighbourhood was known by another name, Holloway Head. Then following the cessation of the Second World War improvements planned for the district brought with it the phrase and subsequently a new name the Bath Row Redevelopment Area. This redevelopment was undertaken between 1960 and 1970 and attracted another change of name to the familiar Lee Bank. Both Bath Row and Lee Bank districts derived their names from two main roads that ran through the area. However by the twenty-first century this had changed once more to Attwood Green after Birmingham's first Member of Parliament Thomas Attwood.

Regardless of what name the district was called the land was located between Edgbaston, Ladywood and the Birmingham City Centre within a triangle of major roads. Roughly they were Bristol Street, Lee Bank Road (later Middleway) and Bath Row to Holloway Head. Originally within and along these roads were built many thousands of working class terraced back-to-back houses dating from the 1800s. It was the overcrowding and unhealthy conditions that the families of these houses endured that brought about the first major redevelopment. Following the demolition of the nineteenth-century houses, shops and factories the Lee Bank district was rebuilt by 1970s into a large council estate with a mixture of housing, tower blocks, low-rise flats and maisonettes, part of the Birmingham City inner ring of districts.

Unfortunately for a number of reasons the Lee Bank redevelopment was not a success leading to demonstrations by the tenants over the condition of the properties. By 2000 this resulted in Birmingham City Council handing over, with the agreement of the majority of Lee Bank tenants, land and property to be administered by a Community Housing Association. Four

other estates were also handed over at the same time, they were the (Edgbaston) Woodview estate the (Highgate) Benmore estate together with the Five Ways and The Sentinels estates collectively the five estates have been merged under one called Attwood Green.

Redevelopment of Attwood Green began on the largest portion of the new estate the former Lee Bank, even this was given a new name now Park Central. Along new and old roads selective tower blocks, low rise flats and maisonettes have been renovated whilst others were demolished and new modern apartment blocks and houses have been created catering for both private and social housing needs. Two new green spaces entitled East Park and West Park now occupy some of the land on one side of Lee Bank Middleway land that once housed some of the Victorian back-to-back properties. Bath Row where the Birmingham Accident Hospital (the Acci) and Davenports Brewery were situated has been built over with new properties. Most of the public houses have gone and stores like Bradshaws where most families in the area did some of their shopping have not been replaced. Land where the Bristol Cinema once stood now houses a Macdonald's burger restaurant and even the usage of St Thomas's Church grounds has not escaped change.

Although it was not possible to include every street and every change that this district underwent through time most of the above has been captured in the photographic journey Lee Bank to Attwood Green provides. The publication begins at the oldest building still standing, a very familiar landmark to visitors and locals, the war damaged tower of St Thomas's Church Bath Row and follows, roughly, a clockwork direction round the district and concludes overlooking Park Central. We are sure you will enjoy the read and the journey and hope the nostalgia within the book rekindles the many thoughts you have or had of your past or present involvement whether it is remembered through the Lee Bank or Attwood Green districts.

Ted Rudge MA and Keith Clenton

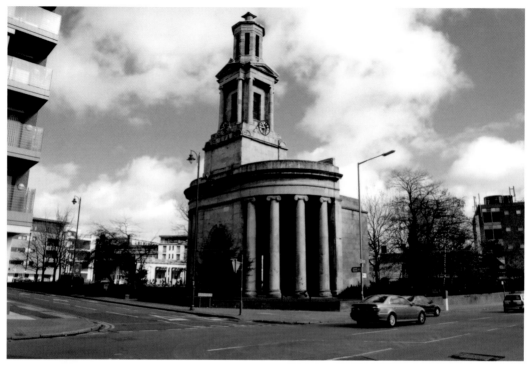

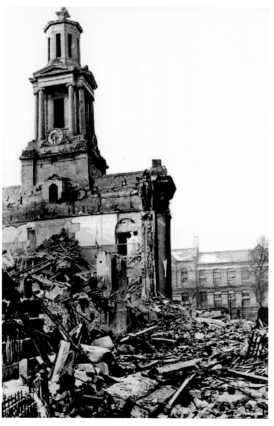

St Thomas Church
St Thomas Church was designed
by Rickman & Hutchinson and
built between 1827-29 on the corner
of Granville Street and Bath Row.
Following the heavy German bombing
raid on Birmingham during 11
December 1940 the church was virtually
destroyed only the tower survived and
now the tower outdates most of the
buildings in this district.

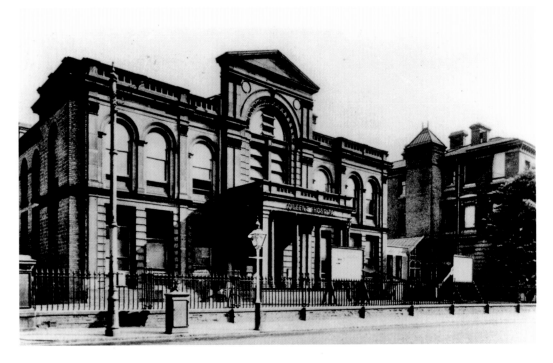

Queens Hospital

Situated a short distance from St Thomas's, along Bath Row, is a building that did survive the hostilities of the Second World War. Originally it was a teaching hospital called the Queens Hospital then in 1941 it became the Birmingham Accident Hospital. This listed building is no longer used as a hospital; it now functions as a student accommodation complex for the University of Birmingham part of the Queens Hospital Close.

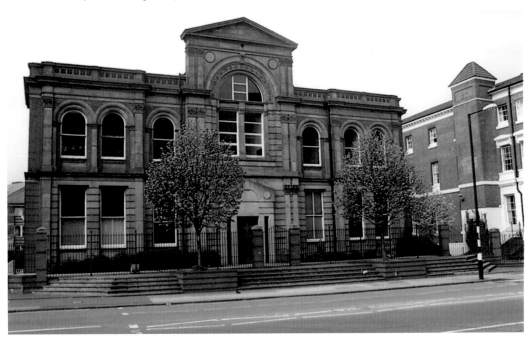

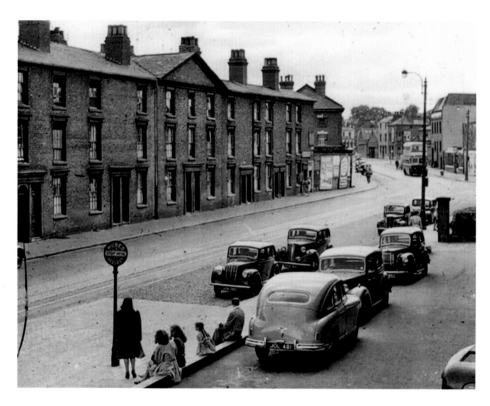

Birmingham Accident Hospital (the Acci)

Sitting on the low wall outside the Birmingham Accident Hospital, known as the 'Acci' by Brummies, was one option whilst waiting for a bus to make its way from Five Ways along Islington Row and down Bath Row. The same view taken from the steps of the same building in 2008 reveals the wall is missing and the bus stop has been repositioned further along Bath Row with trees occupying the land opposite where houses once stood.

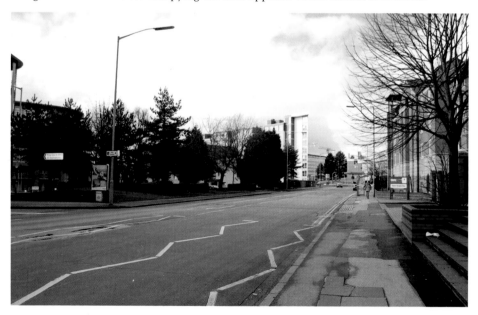

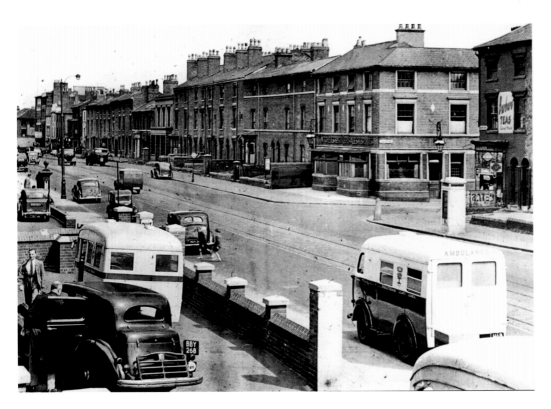

The Acci (Accident Hospital)

A scene looking out over Bath Row from the roof of the Accident Hospital's stock room shows Piggot Street opposite. Contrasting greatly is the 2010 photograph of Bath Row showing the new apartment blocks and offices that have replaced the old Victorian housing when viewed from the steps of the surviving hospital building towards Holloway Head.

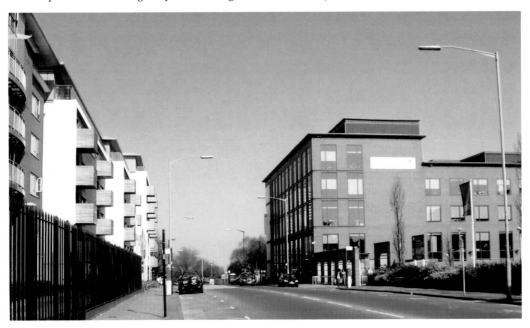

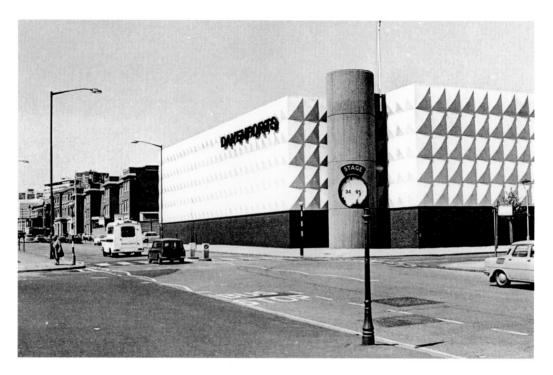

Davenports

Davenports was in the past one of three large brewery firms based in Birmingham they started brewing their kind of beer in 1829. Davenports brewed from property built in 1815 on the corner of Bath Row and Granville Street the original company ceased production from here in 1986. It was renamed the Highgate and Davenport brewery and despite renewed operations and a new frontage shown in the early photograph the premises have subsequently been demolished. Apartments now occupy the six levels above a Tesco store built on the site where the old brewery once stood.

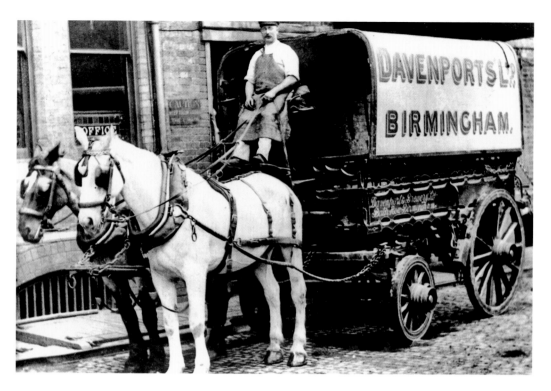

Davenports Horse Power

Distributing millions of bottles and barrels of Davenports beer across Birmingham and beyond has been undertaken through time by a number of transport options. Horse-drawn drays undertook the operation to and from Davenports headquarters in Bath Row during the early years of the company. Today the route that many horses covered travelling towards the city is occupied by motorised transport.

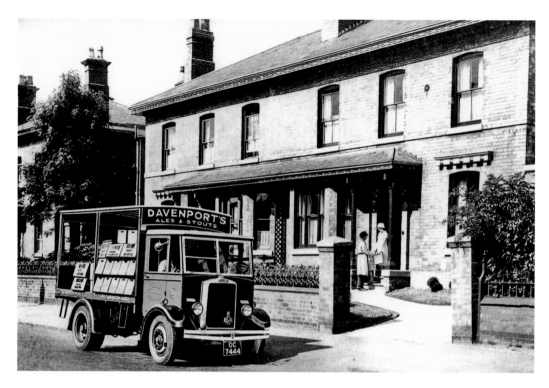

Beer at Home

"Beer at home means Davenports" this was the advertising slogan used by the brewery. In its heyday a fleet of vehicles delivered crates of bottled ales and stouts to customers in their own homes across Birmingham and beyond. It has only been a short period of time since the Davenports vehicles last drove along Bath Row but in the mean time the buildings they use to pass have under gone considerable change.

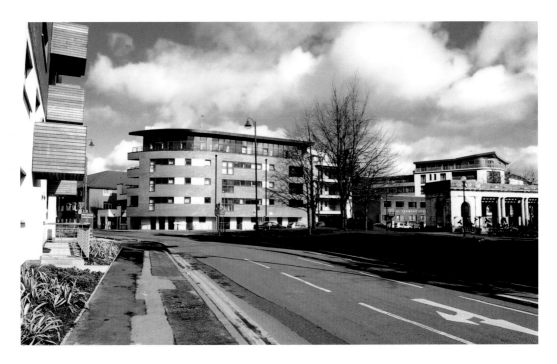

Ridley Street

Ridley Street is located to the right at the far end of Granville Street near Bath Row. Ladywood Garage used to trade from premises on the corner of Granville Street and Ridley Street before it was demolished to make way for a new apartment block. Since its completion in 2010 a new building called the Cube dominates the sky line behind the new apartments.

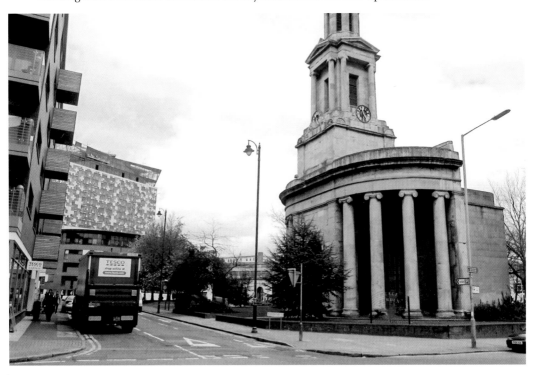

Peace Garden

To make way for a wide, open, pedestrian paved area called "Centenary Square" on Broad Street the peace gardens and Portland stone colonnade built as part of the original Hall of Memory have been moved to a new location in the grounds of the bomb-damaged church of St Thomas Bath Row. Broad Street maintained the arched Hall of Memory building in its original location at the city end of modern Broad Street.

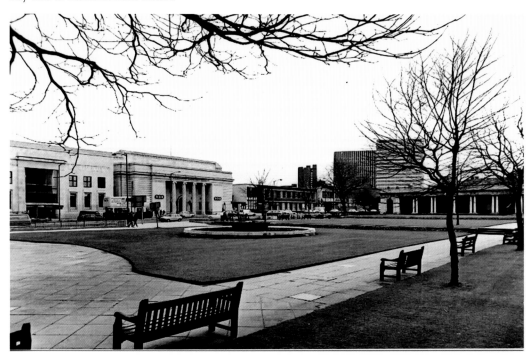

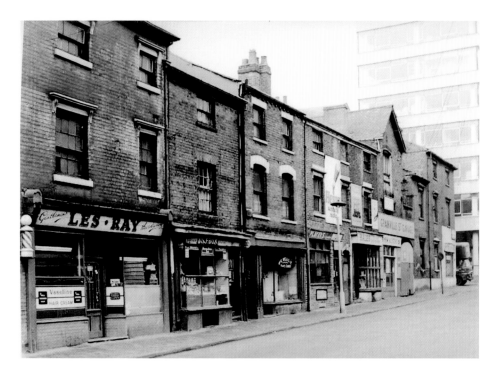

Granville Street

A large office block dominated the corner of Tennant Street and Granville Street in the 1968 photograph together with shops and a garage that were built at a much earlier period. With the older properties having been demolished Granville Street from Broad Street has taken on a completely different outlook with several modern office blocks overlooking trees along one side of this street.

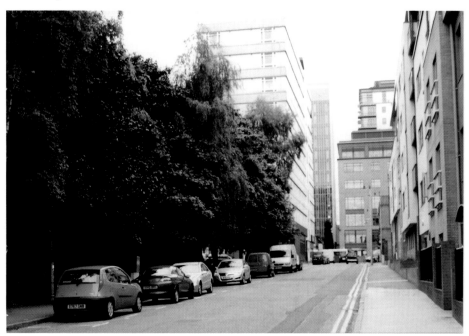

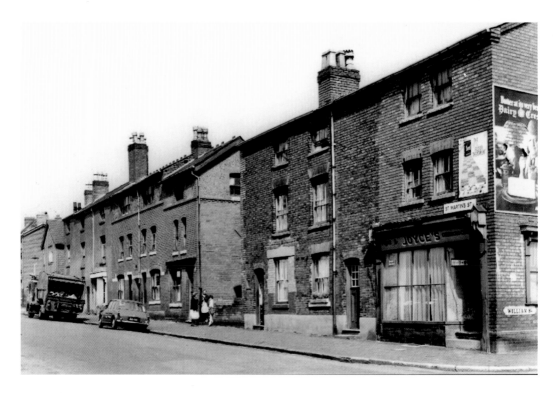

St Martins Street

St Martins Street with William Street off at one time ran from Broad Street through to Bath Row. Now with the Victorian back-to-back working class houses demolished the area has undergone modernisation. This includes a rearrangement of the road system with St Martins Street finishing at Tennant Street where a row of three-storey flats have been built.

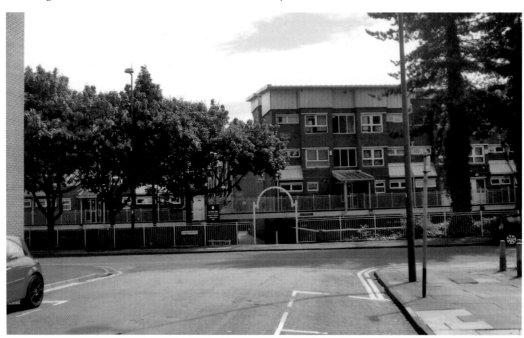

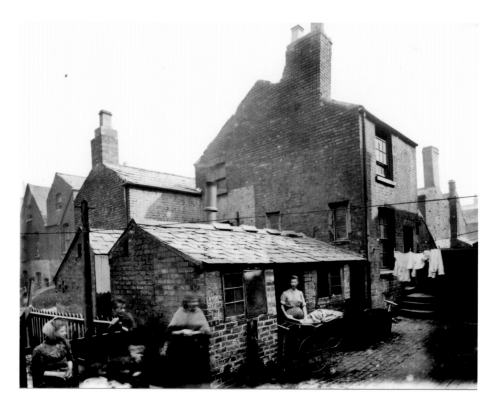

Bishopsgate Street

Two contrasting scenes of buildings built around the middle of the nineteenth century. The imposing ornate City Tavern being one of the few Birmingham public houses to have survived from this period. In the other photograph on the wall of the washhouse (brewhouse) in a typical working class back-to-back courtyard is chalked 11 court Bishopgate Street. Although this photograph was probably taken in the early years of the twentieth century it would be another sixty years before the court was demolished and the street modernised.

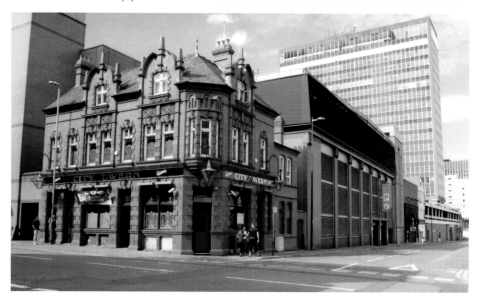

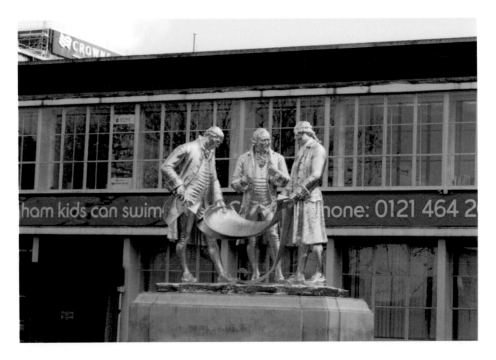

Register Office

Birmingham Register Office no longer looks out on the gold coloured statue of Boulton, Watt and Murdock on Broad Street it has moved around the corner to Holliday Wharf, Holliday Street among a mix of old and new buildings. One new building is the Cube overlooking the scene in Berkley Street. Since the move wedding parties no longer use Centenary Square for their wedding photographs the new register office has its own landscaped courtyard.

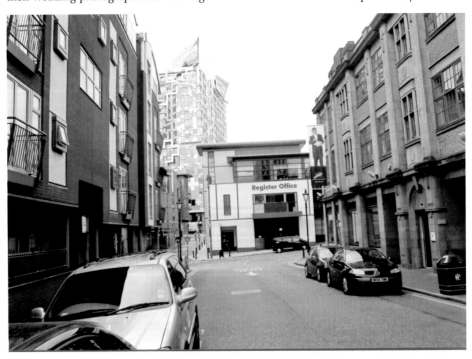

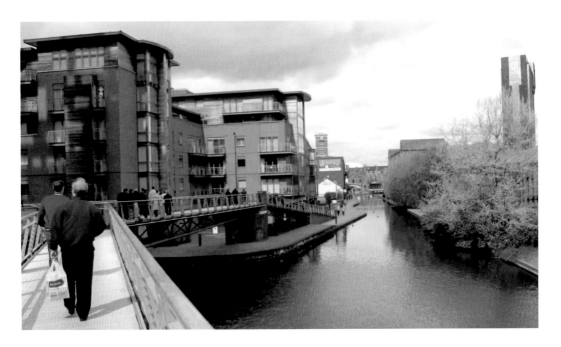

Canals

Located behind Broad Street can be found a legacy from the 1770s, canals, that contributed to Birmingham's rapid growth. Following a remarkable transformation barges now ferry people instead of cargo. All along the towpaths new and converted buildings can be seen adding to the popular business and leisure area this has become. The barge in the picture will encounter a left bend and pass under a bridge travelling towards Granville Street along the Worcester and Birmingham canal.

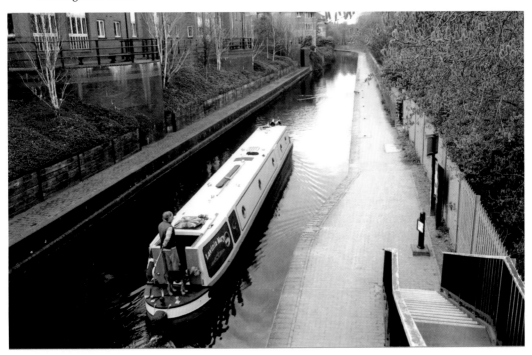

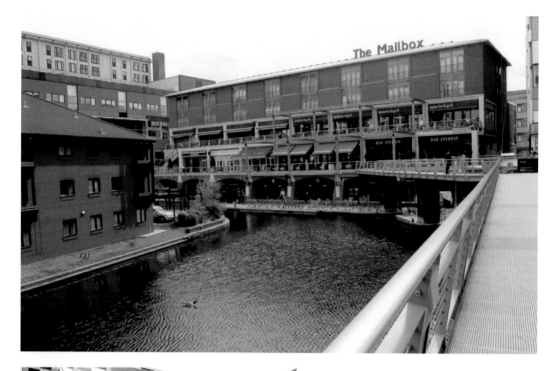

Mail Box and Cube

Two buildings the Mail Box and the Cube are situated side by side alongside the modern Broad Street canal network. The Cube was completed in 2010 and is shown here complete with abseiling window cleaners.

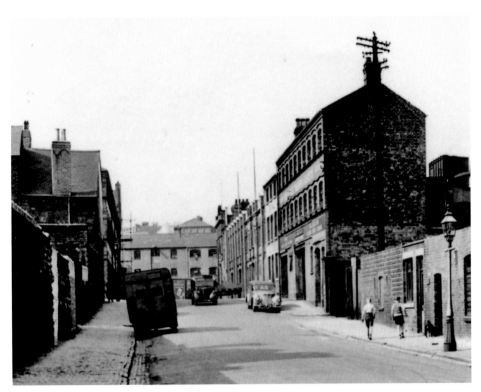

Commercial Street
Two photographs of
Commercial Street one
taken in 1952 from
Severn Street and
again in 2010. Each
image contrasts greatly
between old industrial
buildings dating from
the middle of the
nineteenth century
and a mixture of ultra
modern residential and
commercial buildings.

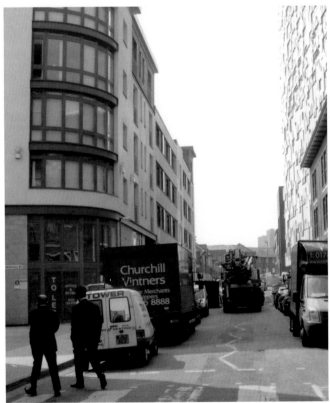

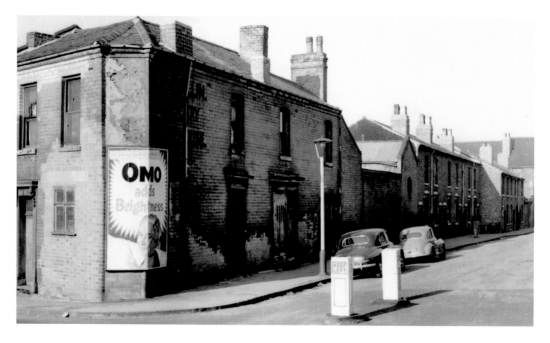

Washington Street

Single storey terrace houses with S. F. Collin Grocery Warehouse existed on the corner of Upper Gough Street and Washington Street just before demolition in the 1960s. Two people approaching the same corner in 2010 with Ridley Street to the left and Upper Gough Street on the right view, an entirely refashioned, prosperous, residential and commercial area with Birmingham's latest high-rise building (the Cube) overlooking them.

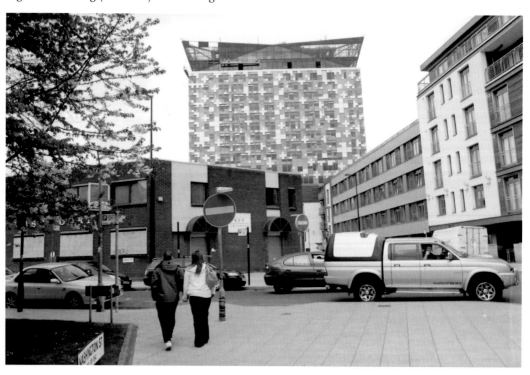

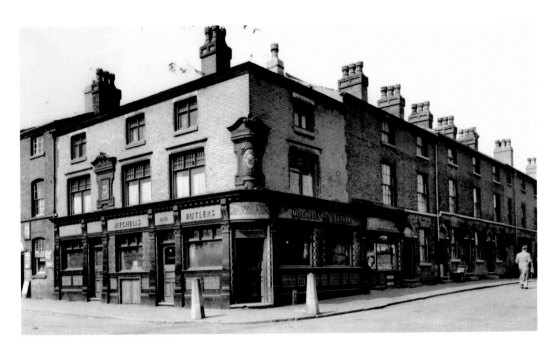

Gough Street

Still standing and open for business on the corner of Blucher Street and Gough Street is The Craven Arms public house. Although the old terraced houses, shops and small businesses have been demolished to make way for modern industrial units, the pub has managed to maintain its beautiful blue Victorian tiled exterior.

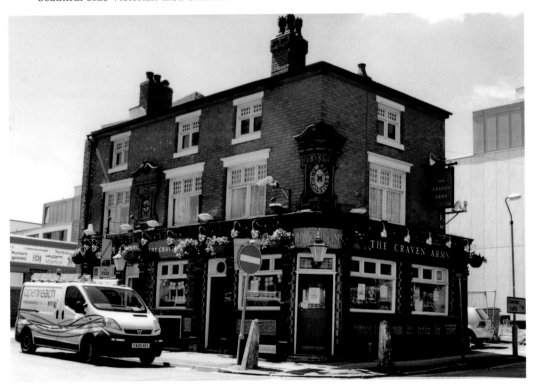

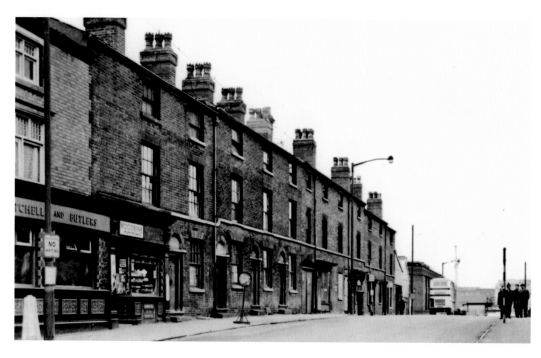

Blucher Street

Blucher Street is another street that lost its residential properties to make way for an assortment of office blocks and small industrial units. Viewed in 1964 from Holloway Head towards Commercial Street and again in 2010 from a point in Holloway Head where traffic has been prevented from entering the street.

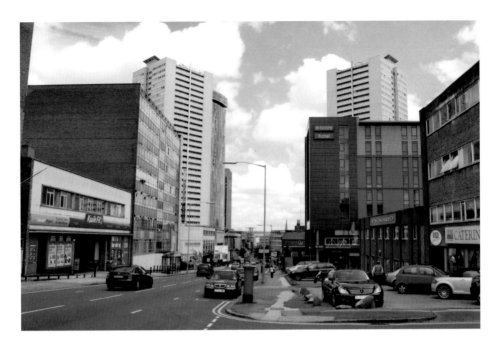

Holloway Head

The skyline, in 2010, viewed from the corner of Exeter Street and Holloway Head towards Holloway Circus is dominated by a hotel and two residential tower blocks. Collectively the latter are known as the Sentinels, Cleveland Tower built in 1970 is on the left with the Radisson Blu (SAS) hotel behind, Clydesdale Tower built in 1971 completes the trio. The Unicorn public house no longer occupies the Exeter Street corner and along with the customer's houses each has given way to the regeneration of this area.

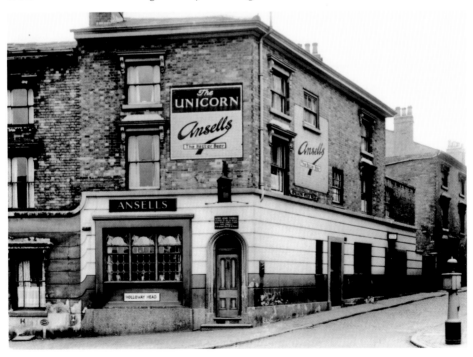

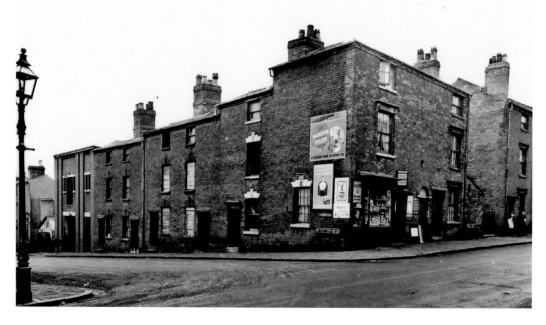

Marshall Street

Occupying the corner of Marshall Street and Holloway Head in 1960 was a typical corner shop that provided for the local community that lived in the adjacent terraced accommodation. A nightclub has now been established where the old houses once stood.

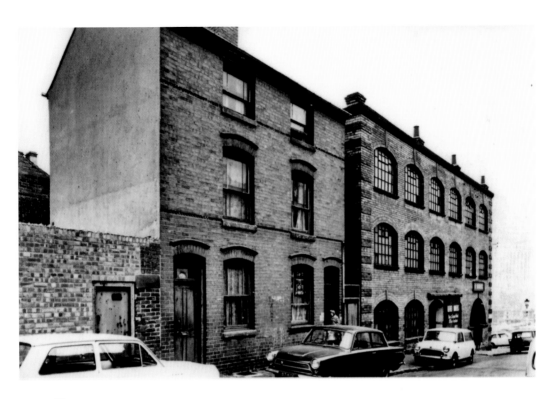

Ellis Street

When the 1965 photograph was taken Ellis Street with houses and factories built side by side ran from Holloway Head to Blucher Street with Singers Hill Synagogue at the far end. An altogether different view of Ellis Street followed the demolition of the old properties. Now a multi-level car park and several new modern buildings with landscaped frontages occupy a shortened version of Ellis Street that now ends at Gough Street.

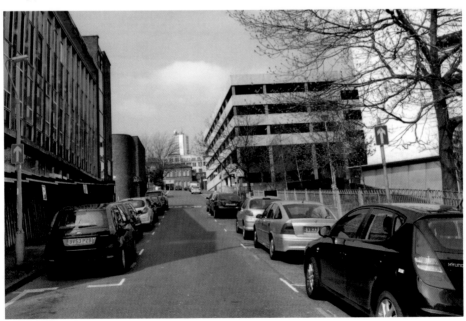

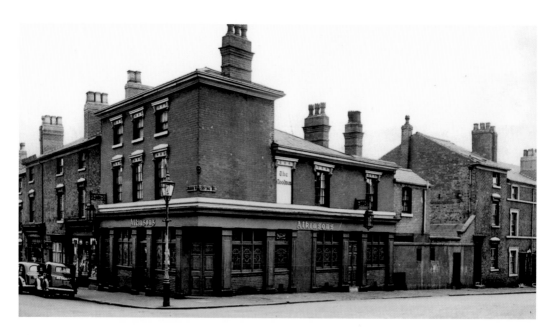

The Woodman

A public house called The Woodman was once part of a shopping centre on a busy cross road where Cregoe Street, Latimer and Irving Streets converge. The pub was demolished in a redevelopment programme during the 1960s together with the shops and houses. They have been replaced by various types of modern architecture that are now overlooked by the tower of St Thomas's church and the latest addition to the area, the Cube.

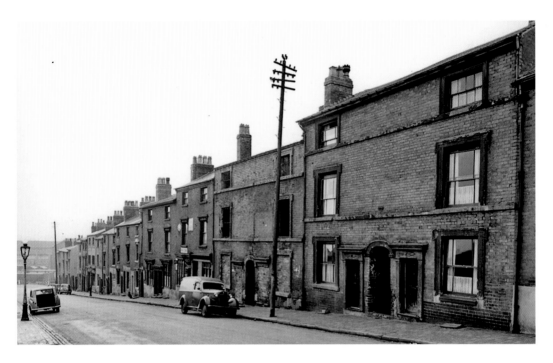

Cregoe Street

From Bath Row along Cregoe Street back-to-back housing was very prominent along this side of the street. There are passageways (entries) between houses that led to open courtyards where further back-to-back houses and the domestic facilities shared by families living in them are housed. Various other types of domestic properties now occupy this street some have gardens attached.

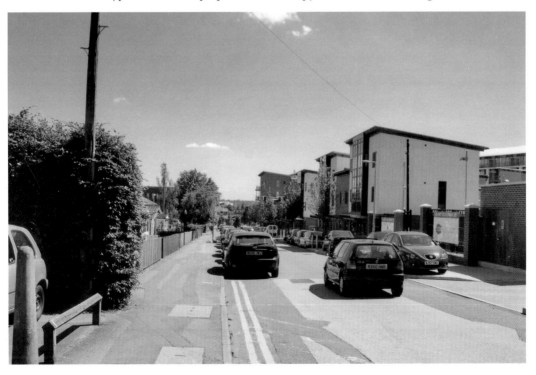

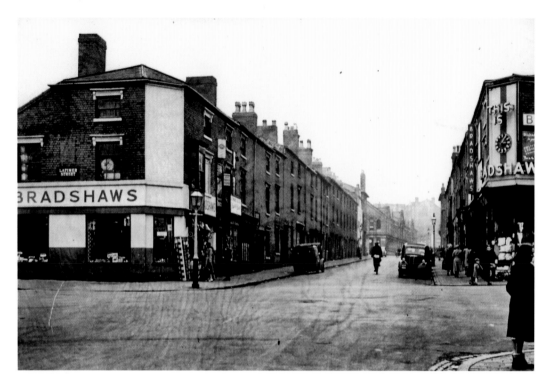

Bradshaws

Bradshaws catered for the domestic needs of the local working class families from their stores on each corner of Latimer Street and Cregoe Street before it finally closed in the 1960s. Today a four-storey apartment block with a Tesco store on the ground level occupies approximately where Bradshaws once was. A sign on the lamppost shows the way to Park Central where East and West Park and the latest social and private housing developments are located.

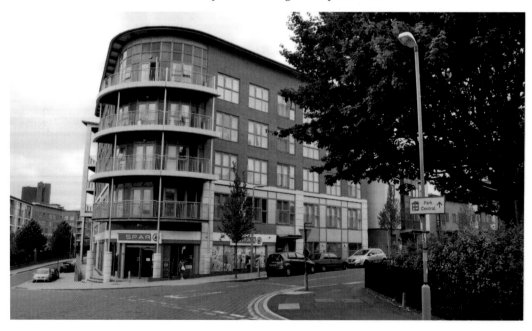

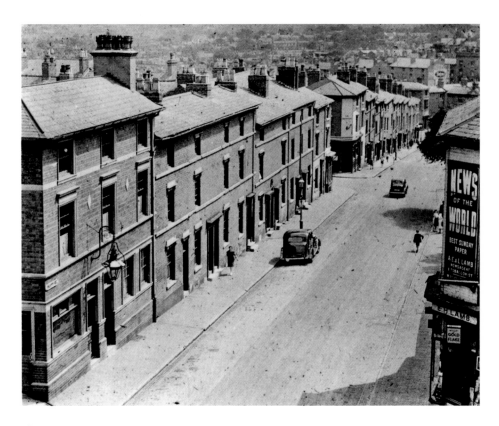

Piggott Street

An early photograph taken by a patient from a window in the Accident Hospital over looks Piggott Street. Piggott Street once ran between Bath Row and Great Colmore Street but under the redevelopment scheme that absorbed Lee Bank into Attwood Green, Piggott Street was removed. A recently taken photograph of the approximate position Piggott Street once occupied reveals a row of modern domestic buildings.

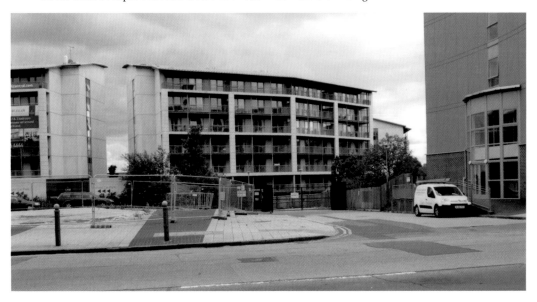

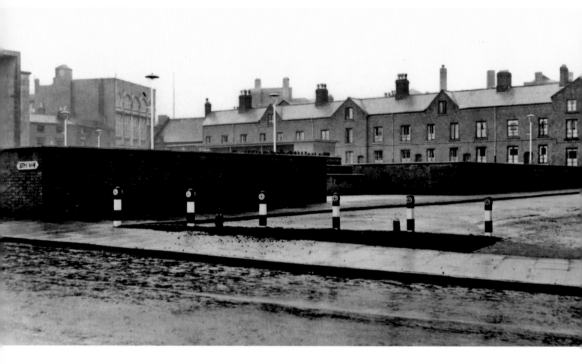

Washington Street

Traffic before the 1960s was not permitted to enter Washington Street where it meets Bath Row, bollards across the street prevented this happening. Alterations that occurred after this photograph was taken have not improved this situation. Bollards still restrict traffic alongside trees that front the bomb-damaged church of St Thomas.

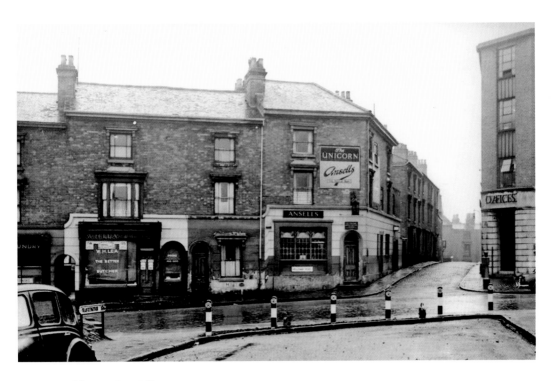

Speaking Style Walk

From the end of Washington Street across Holloway Head in the 1960s The Unicorn public house was on one corner of an intriguingly named thoroughfare entitled Speaking Style Walk that lead to Irving Street. In 2010 the same view looks over the far side of a sports ground that belongs to a school in Great Colmore Street.

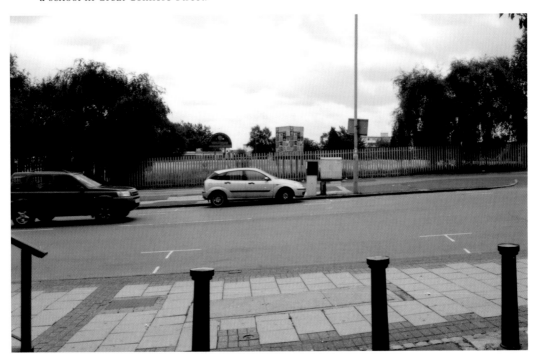

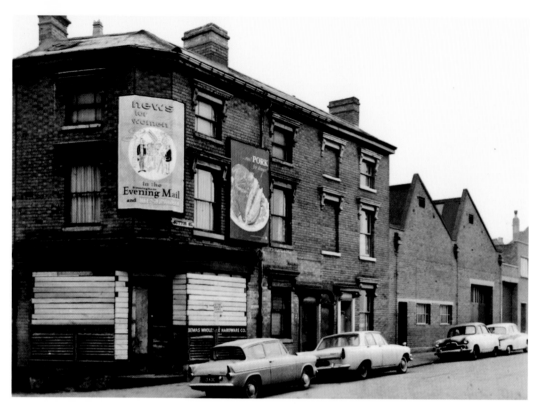

Sutton Street

In 1964 property on the corner of Sutton Street and Holloway Head is shown boarded up ready for demolition. With scaffolding around the same corner in 2010 it appears major construction work is being carried out on what was subsequently built.

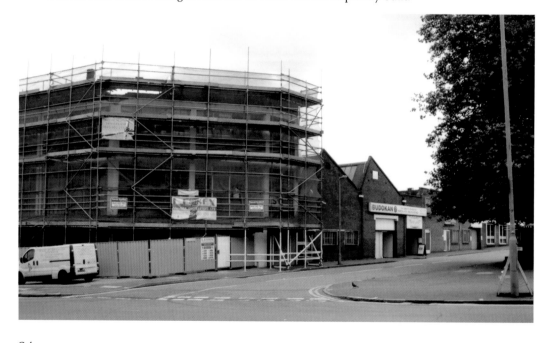

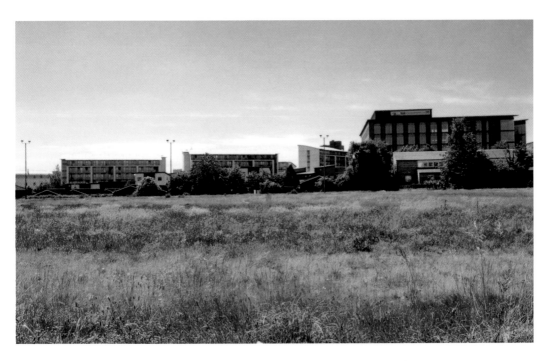

Tower Block Demolition

Following the clearance of many hundreds of back-to-back houses in the 1960s the replacement build was usually maisonettes or high-rise tower blocks. Viewed across open land from Sutton Street in 2001 a tower block was visible however by 2010 the same view reveals the tower block has been demolished.

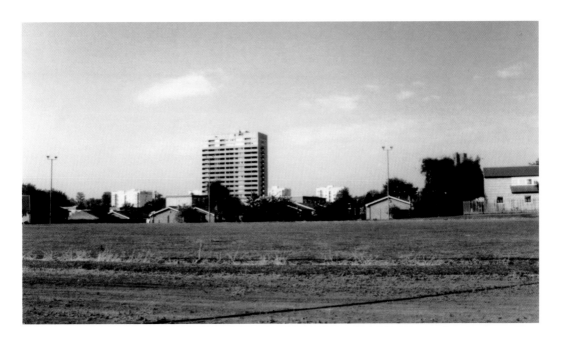

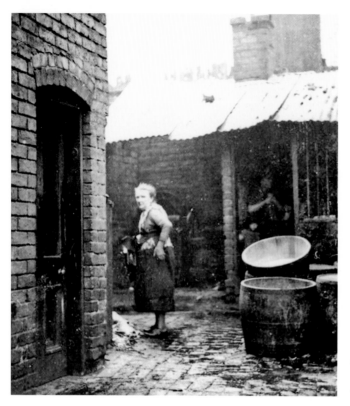

Florence Street

Living conditions in a back-to-back courtyard in Florence Street was no different to the majority of local properties in this area during 1933. Another three decades would pass before they were demolished and brick built work units replaced them, visible from Holloway Head. Like the lady in 1933 the man in 2010 is also holding his side when walking towards the open doorway of a car repair workshop in Florence Street.

Ernest Street

Along both sides of Ernest Street in 1958 were different types of factories that provided work for many local people. Today with the factories long gone the 131 bedroomed Ramada Encore Hotel occupies most of the left hand side of Ernest Street with the main entrance on Holloway Head.

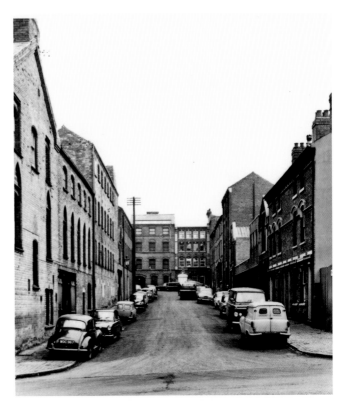

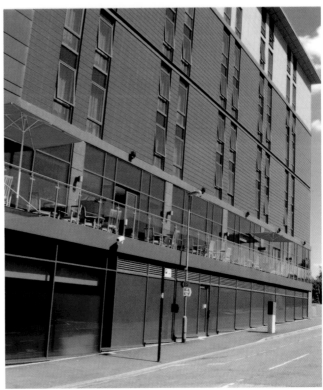

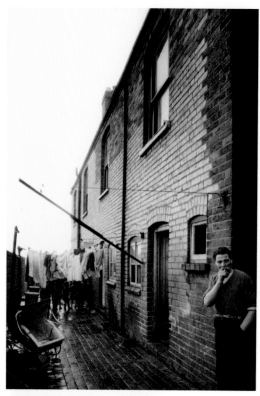

Exeter Place

An attempt to keep properties of this age still habitable is expressed in the 1960s photograph where a large portion of the wall has been rebuilt along Exeter Place that was accessed via Exeter Street off Holloway Head. Crowded living conditions have been captured in the photograph of a row of single-storey terrace houses where washing hung on the clothes line most of the day and one tenant is seen having a cigarette outside. Exeter Street today is a mixture of different factory units.

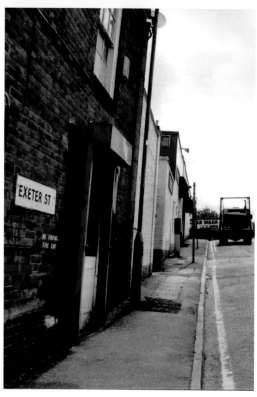

Windmill Street
Towards Holloway
Head from the top
of Exeter Street in
1955 Windmill Street
is shown with a
large building on the
corner. Over the next
fifty years the outlook
has changed Exeter
Street and Windmill
Street now has a
car wash and a tyre
replacement centre
built on the corner.

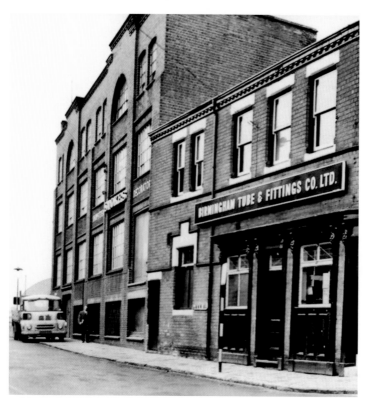

Bow Street
Little change has taken place on the corner of Bow Street and Windmill Street from when the Birmingham Tube & Fittings occupied it in 1965. Same building is there in 2010 but the workers and the Birmingham Tube & Fittings no longer operate from there.

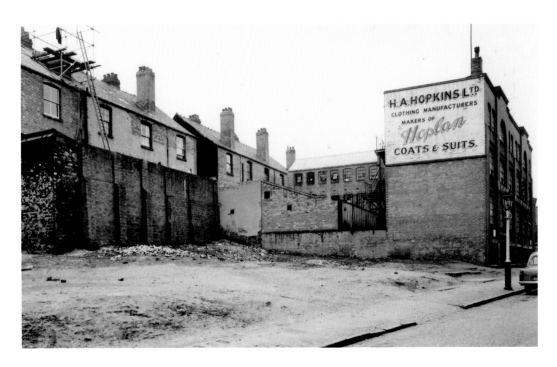

Factory on Bow Street

On the left hand side of Bow Street from Irving Street towards Windmill Street a bare piece of land existed in 1956, possibly Second World War hostilities, and a building occupied by the Hopkins Clothing Manufactures with houses behind. In 2010 the houses have been demolished but the clothing factory building is still there and Clydesdale Tower one of the Sentinel high-rise block of flats has been erected close by.

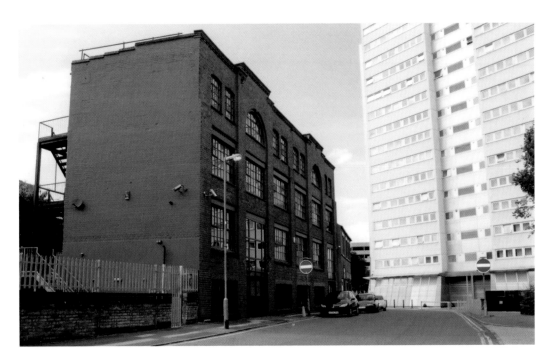

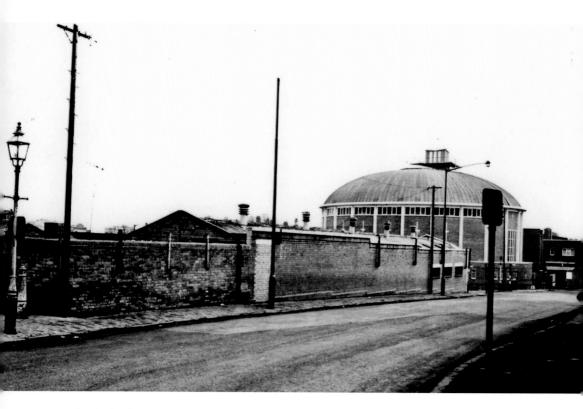

St Catherine's Church

The rear of St Catherine of Siena Roman Catholic Church is visible at the far end of Bow Street in 1965. The domed church building replaced one that had existed in the old Horse Fair since 1875, it was subsequently demolished in the first redevelopment of this area in the 1960s. In 2010 street parking appears to be a problem with double yellow lines on one side of the road and outside the rear of the 'O$_2$ Academy' an entertainment centre that once was called the Dome Night Club.

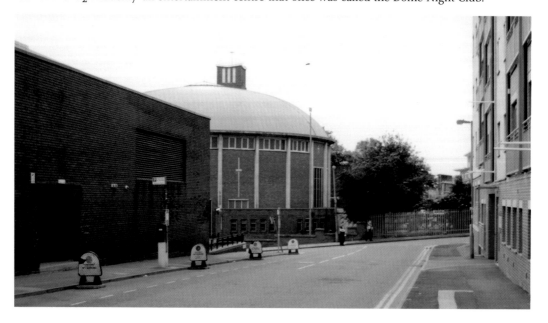

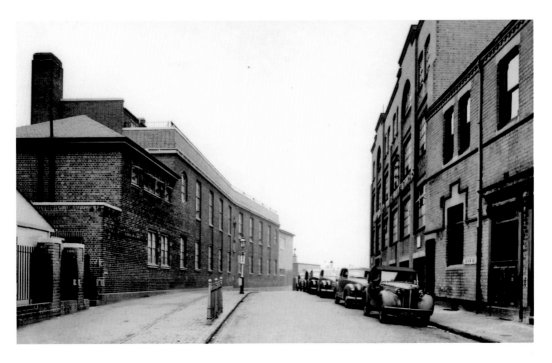

Bow Street

Industrial units along Bow Street in 1956 have over time been replaced by more modern industrial units and office blocks. Both views are from Irving Street towards Windmill Street where in 2010 the Radisson Blu Hotel and Clydesdale Tower one of the Sentinel high-rise tower blocks are visible in the distance.

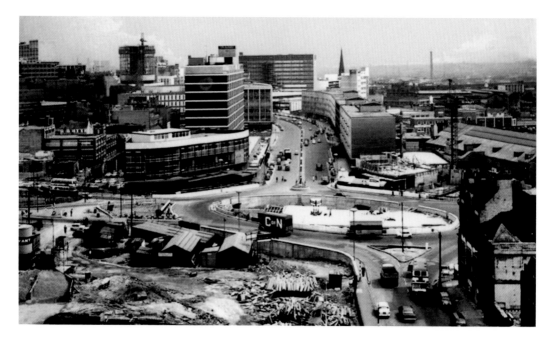

Holloway Head

The elevated outlook from Holloway Head along Smallbrook Queensway towards the Birmingham Bull Ring area shows the spire of St Martin's Church in the distance. Holloway Circus, Queensway was under construction in 1963 as part of the redevelopment that linked Bristol Street with Suffolk Street Queensway. The Radisson Blu Hotel and Cleveland Tower, one of the Sentinel tower blocks, dominate the view at the bottom left hand side of Holloway Head in 2010.

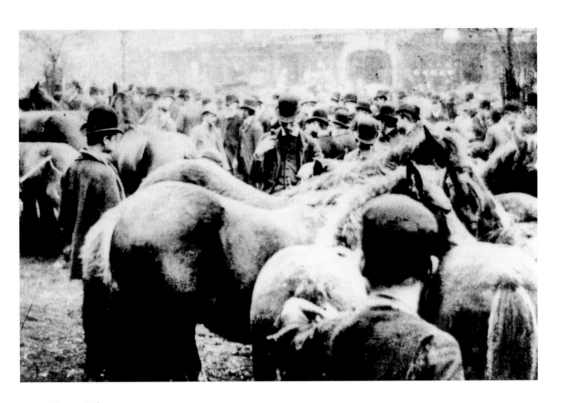

Horse Fair
During the period when horses were the main source of power pulling the transport and carriages around Birmingham the Horse Fair located at the end of Bristol Street was very well attended. Today the road name lingers on but it has been a long time since horses were traded from this old market place.

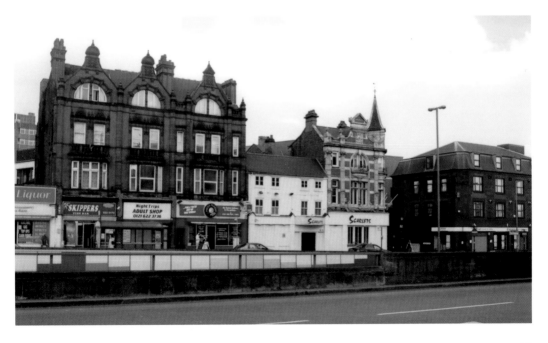

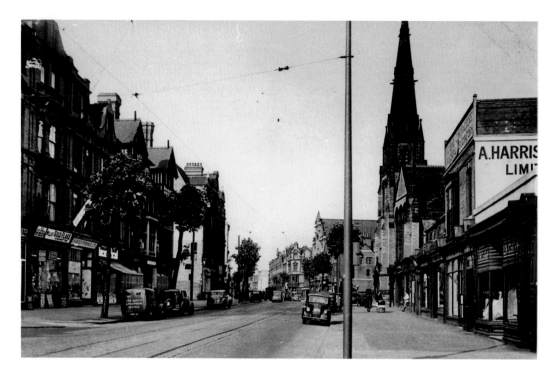

Bristol Street

A glimpse of Bristol Street in 1949 when parking the car, if you had one, was not a problem even the unused tram lines still occupy the middle of the road. By 2004 when the Raddison Blu Hotel was being built the traffic used a dual carriageway into and out of Birmingham centre and the skyline had vastly changed with many high-rise buildings looking down on Bristol Street.

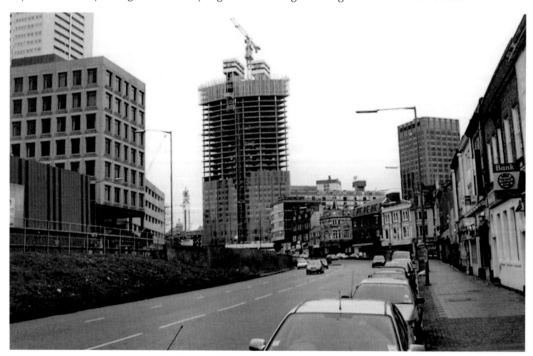

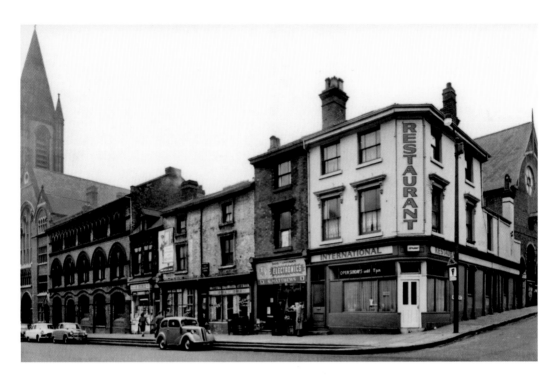

Bristol Street Horse Fair

Between the present Holloway Circus Queensway and Essex Street the remaining part of the Horse Fair can be found. Prior to the reconstruction of the area in the 1960s the Horse Fair was on both sides, at the city end, of Bristol Street. The double curbstone in the early photograph is near Windmill Street where people mounting horses used it to get on and off when trading was carried out on this side of the Horse Fair.

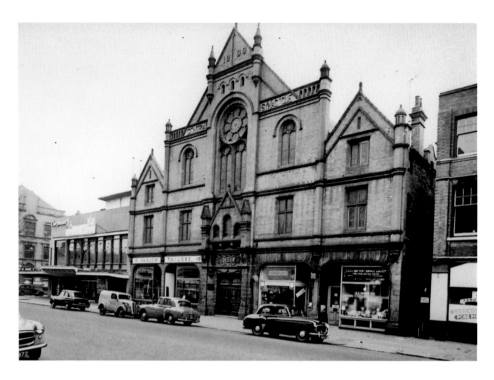

Bristol Street Churches

There are two religious buildings. One situated at 129 Bristol Street was a Methodist hall before 1928 then it was used by the Birmingham Central Synagogue until 1961. The brick building shown here in 1957 has been demolished. The photograph of the other church St Lukes was taken in 1954. Today a church building still stands on the corner of Bristol Street and what is left of St Lukes Road is now a cul-de-sac.

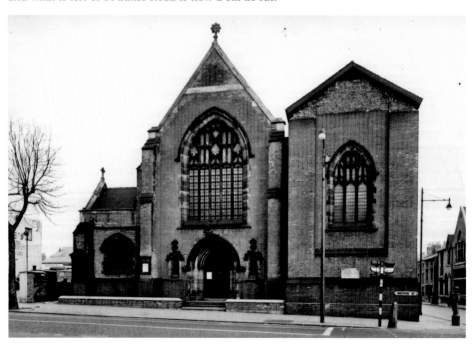

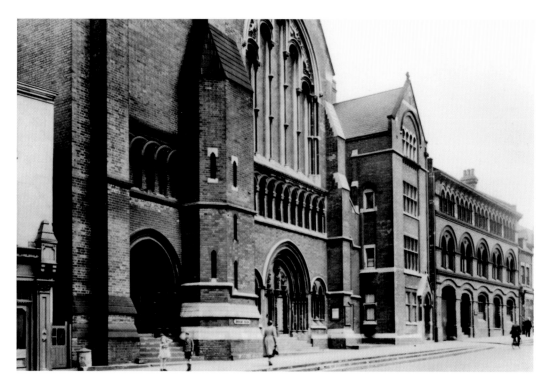

St Catherine's

The first St Catherine of Siena Roman Catholic church stood on the Horse Fair side of Bristol Street and was opened in 1875. In 1964 this grand building was demolished along with the old back-to-back working class housing that many of St Catherine's parishioners occupied. A new church of a circular design has been erected near to where the old church once stood.

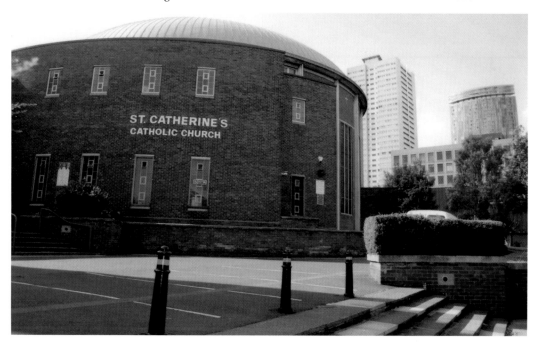

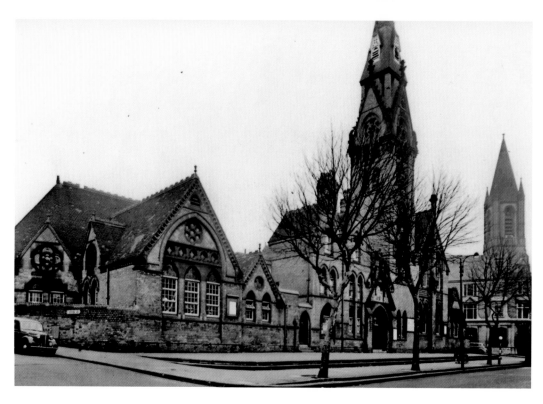

Irvine Street School

Several of Birmingham's Board School buildings that were built in the late 1800s have survived in one form or another but Irvine Street School (Bristol Street Board School) on the corner of Irving Street and Bristol Street was in the way of a road widening scheme and was subsequently demolished in 1960. Occupying the corner in 2010 is the 'O$_2$ Academy' entertainment venue over looked by Clydesdale Tower.

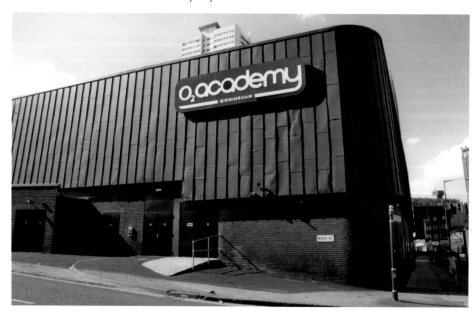

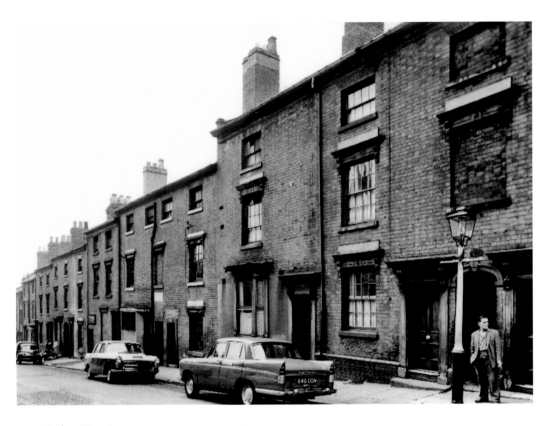

Irvine Street

There were a large number of terraced houses in Irvine Street with entries between them that lead to court yards where more houses were located in 1961 when the early photograph was taken. All this was eventually demolished and spacious modern living accommodation has been provided over the years that followed with trees sited along the street.

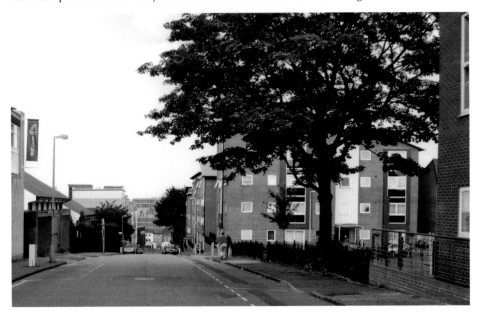

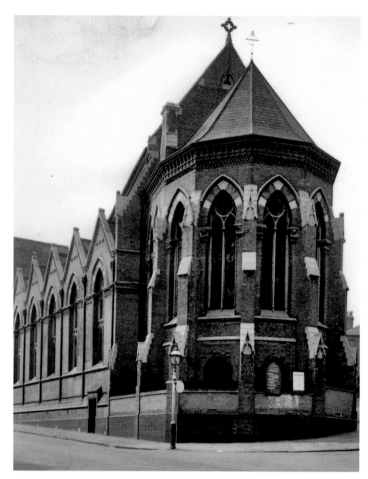

St Asaph Church
Since 1869 on the
junction of Great
Colmore Street
and Latimer Street
St Asaph Church
designed by Yeoville
and Thomason stood.
Latimer Street and the
church disappeared in
the redevelopment of
the area in the 1960s.
Approximately where
St Asaph Church once
stood in Great Colmore
Street modern housing
and small factory
units now occupy the
position.

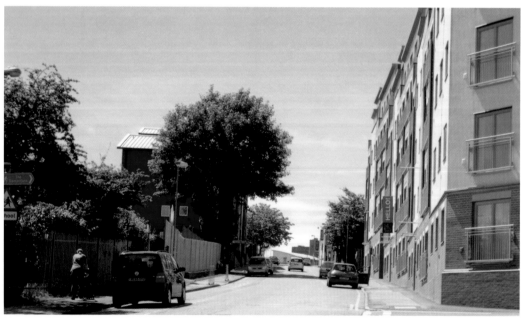

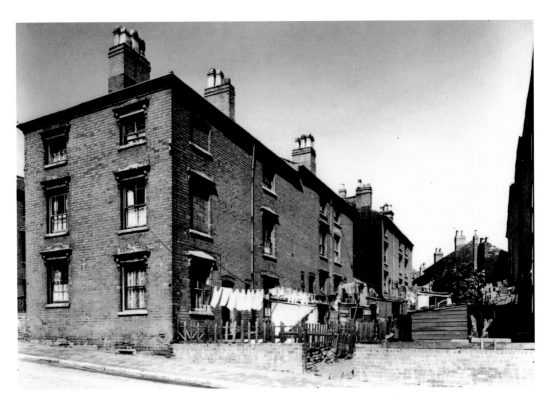

Latimer Street

Not all the family washing facilities were communal in Lee Bank, in this 1961 photograph a line of washing is blowing in the wind from a garden in Latimer Street. The Colmore Arms public house a little way further down the street was located near the junction with Great Colmore Street all this has been bulldozed to make way for the first redevelopment of this area.

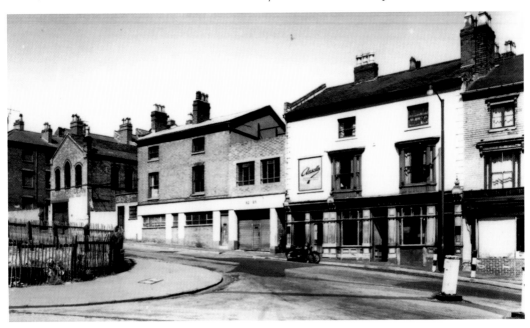

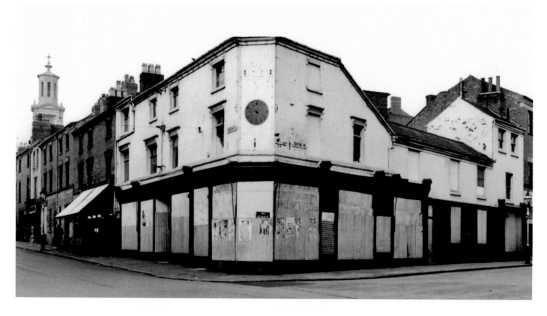

Cregoe Street and Irving Street

Boarded up ready for demolition on the corner of Cregoe Street and Irving Street is Bradshaws old building overlooked by St Thomas church tower in Bath Row. Bradshaws was a renowned local store that supplied household goods from their shops around this location where six roads intersected. By 2010 this locality has a completely different vista with Langley Walk now being watched over by the old church tower in an area now called Park Central.

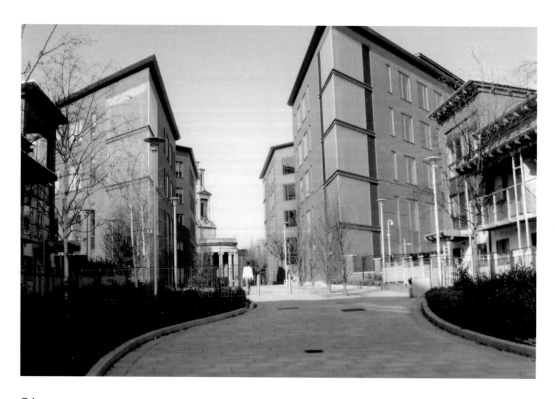

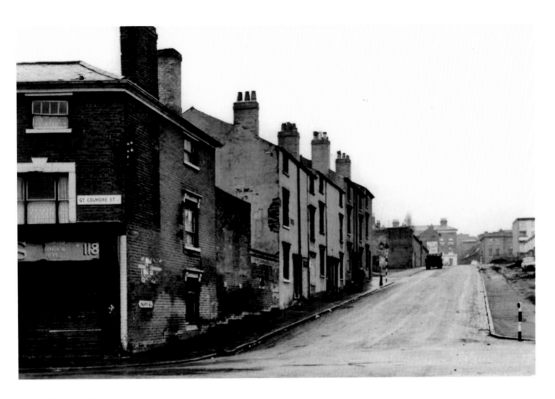

Piggott Street

Piggott Street was built between Bath Row and Great Colmore Street in the 1800s, the street looks rather depleted in the 1960s during its final years before redevelopment. The buildings that replaced them in the 1960/70s have again been replaced by those in Mason Way, West Park a road that joins the rearranged Great Colmore Street and Cregoe Street.

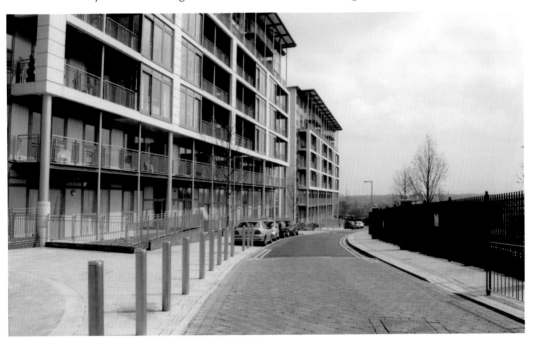

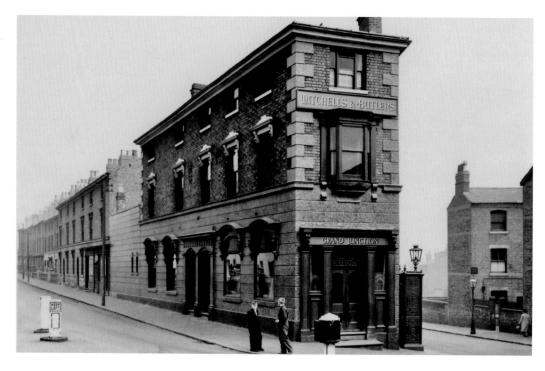

Great Colmore Street

A Victorian gentlemen's public urinal was situated alongside the Grand Junction public house located where Great Colmore Street meets Bell Barn Road which was close to the Bell Barn shopping centre. Further down the street was the Great Colmore Garage wedged between a small shop and two-storey terraced houses. This typical Lee Bank scene was eventually erased during the 1960s redevelopment of this area.

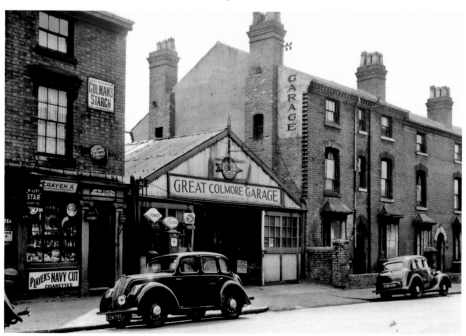

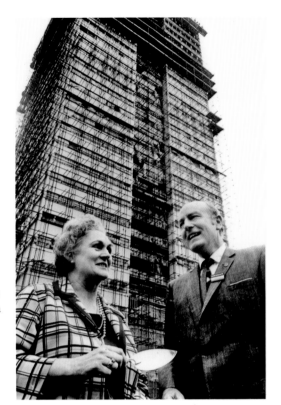

Tower Blocks

High-rise tower blocks were built in the 1960/70s to re-house families that had once occupied the Victorian houses that were demolished in the redevelopment of the Lee Bank district. Domestic facilities provided in the newly built tower block flats certainly offered the tenant a better standard of living. Nevertheless in the following decades many were demolished yet some still stand today like Cleveland Tower seen in June 1970 having just been completed.

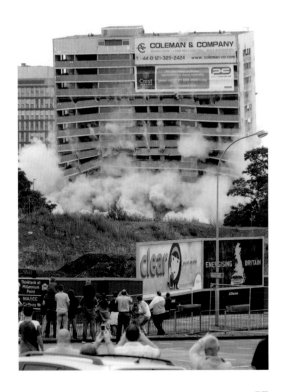

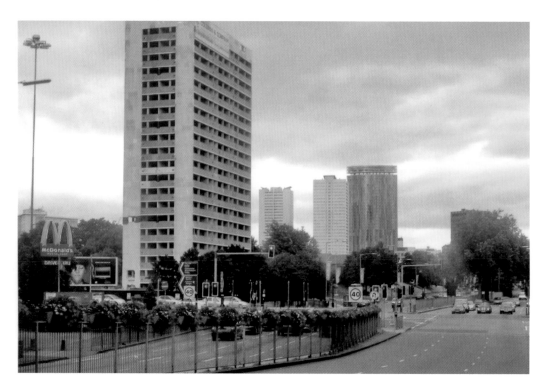

Disappearing Tower Block

Two photographs taken twelve days apart along the Bristol Road just before the road becomes Bristol Street. The first one was taken on the 18 July 2006 and displays a high-rise tower block and a MacDonald's takeaway at the Lee Bank Middleway junction. Same scene on the 30 July 2006 reveals a pile of rubble behind a newly-erected brown road sign near McDonald's.

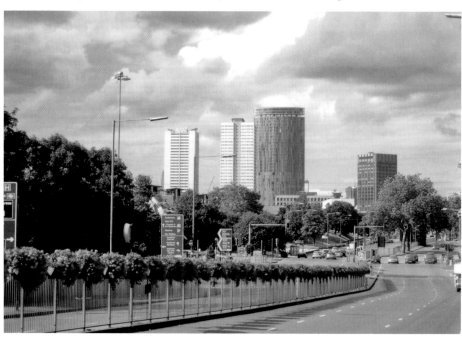

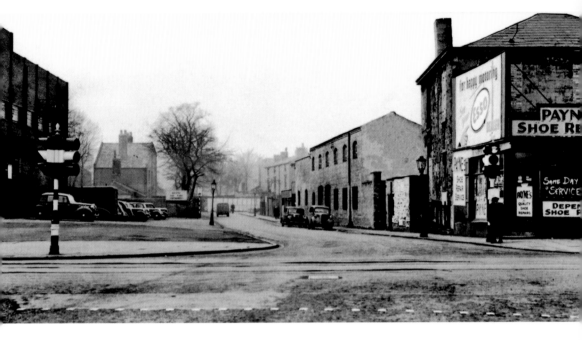

Sun Street Bristol Street Junction

On the crossroads that is now the beginning of Lee Bank Middleway with Bristol Road and Bristol Street once stood Sun Street. The Bristol Cinema occupied one corner of Sun Street and Paynes Shoe repairer shop the other. Sun Street, the cinema and the shoe repair shop were removed to make way for the major road junction that currently exists at this location.

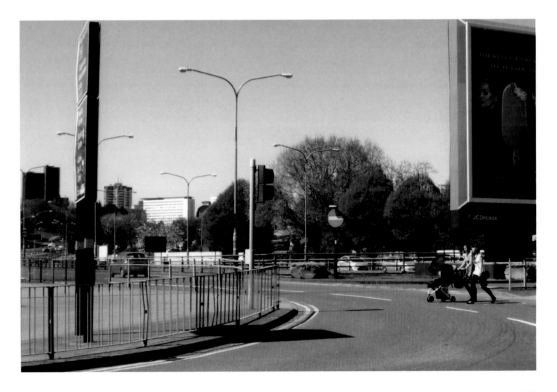

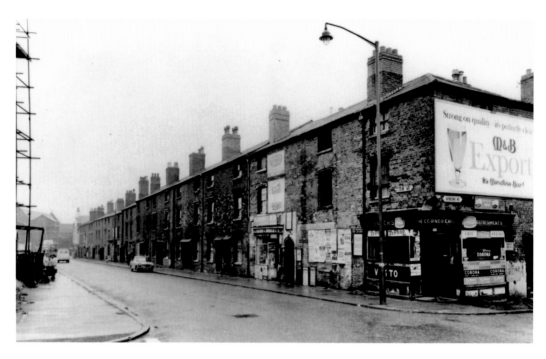

Spring Street

Before the building of Lee Bank Middleway Sun Street ran from Bristol Road to the centre of Spring Street which was a continuation of Spring Road that eventually joined Wynn Street at Bell Barn Road. Sun Street no longer exists following the demolition that cleared the way for the construction of Lee Bank Middleway but although a part of Spring Street has survived it has not as yet been developed.

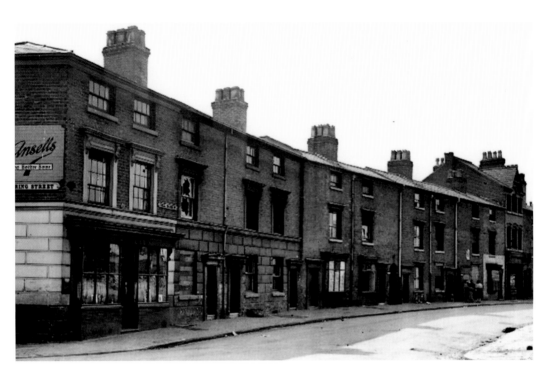

Bell Barn Road – Spring Street

Bell Barn Road use to start and finish further along Great Colmore Street. Approximately half way along Bell Barn Road was Spring Street that had an off-license on one corner. Following the latest redevelopment at the same location a section of Park Central called East Park has been created with railings in front.

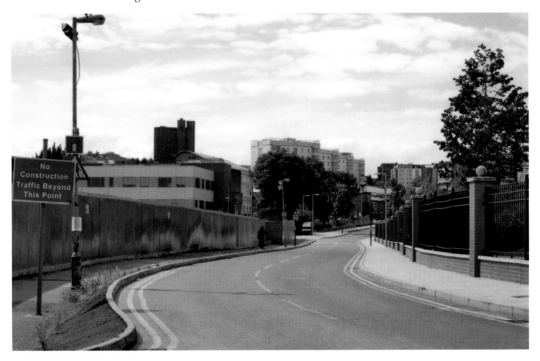

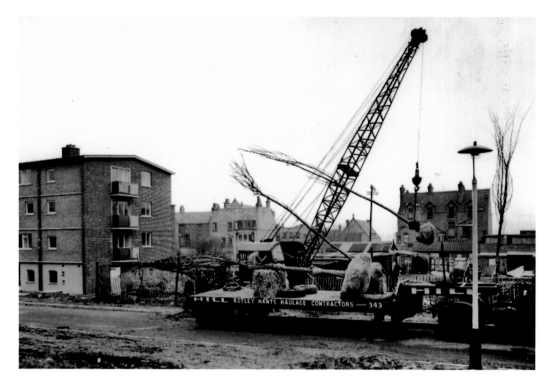

Bell Barn Road

Two redevelopments each from a different time along Bell Barn Road are represented in these two photographs. Trees lifted by a crane are being planted next to a block of new masionettes built following the demolition of the old terrace houses in the first redevelopment of Lee Bank during the 1960s. Now a completely different environment has been created by 2010 with the creation of Park Central within Attwood Green.

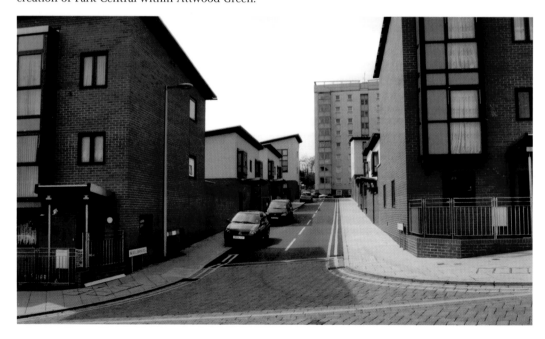

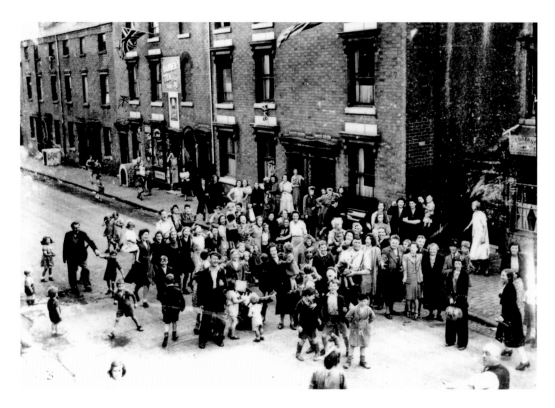

Bell Barn Road

Families in Bell Barn Road are enjoying some kind of patriotic gathering in 1948 with union jack flags fluttering from attic windows and a piano being played outside one of the old back-to-back houses. Overcrowding does not appear to be a problem sixty two years later in the newly built Bell Barn Road looking down towards Lea Bank Middleway

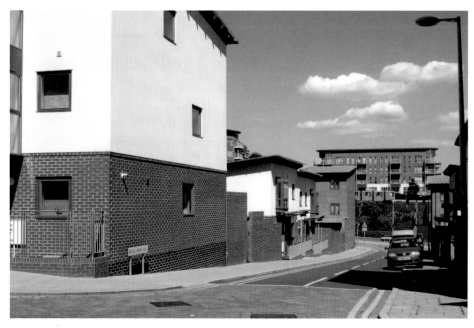

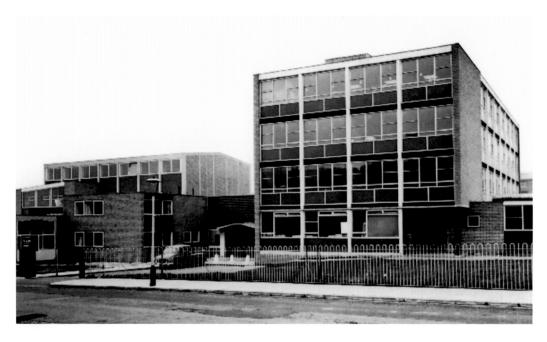

Schools

An educational complex on Bell Barn Road that has had various name changes over the years the two schools in the photographs were in 1961 the Lee Mason School and in 2010 the James Brindley School.

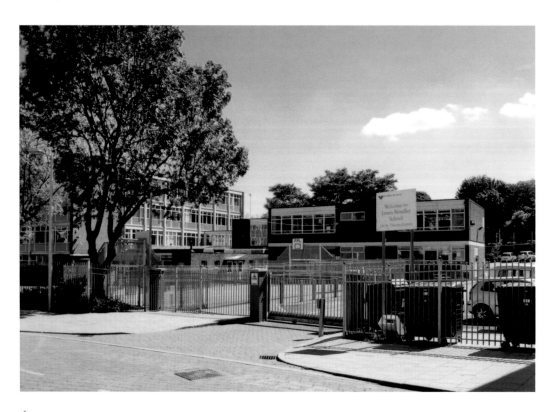

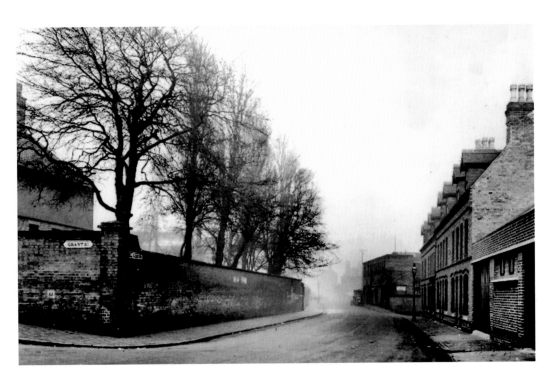

Grant Street

Bell Barn Road with a Vicarage behind a long wall existed on the corner of Grant Street. Grant Street was heavily damaged by German aircraft on 19 November 1940 affecting nearly 300 homes and killing five people. The old houses that remained were finally demolished in the redevelopment of the area in the 1960s. Today subsequent to another improvement of the district Grant Street has been realigned with Wynn Street.

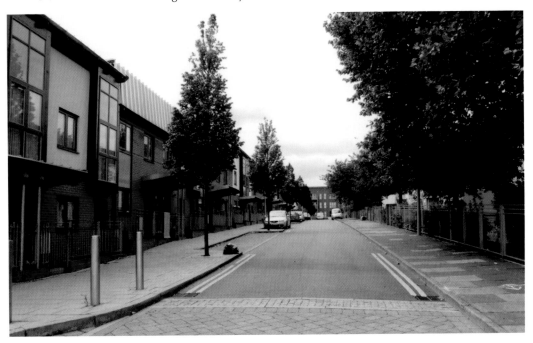

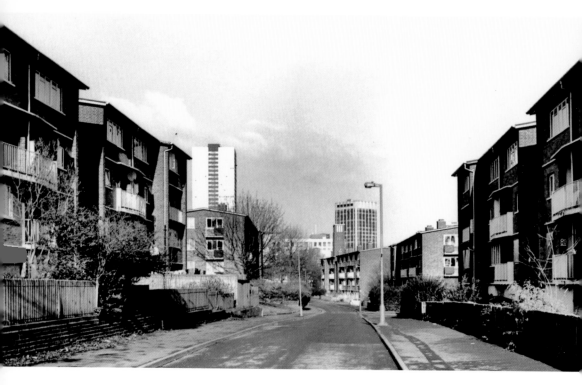

Rickman Drive Housing

Part of Bell Barn Road was renamed Rickman Drive when the maisonettes that replaced the nineteenth-century back-to-back houses were built. The maisonettes were probably just over thirty years old in 1997 when this photograph was taken. Another rebuild demolished the masionettes in favour of the current housing shown in the 2010 photograph.

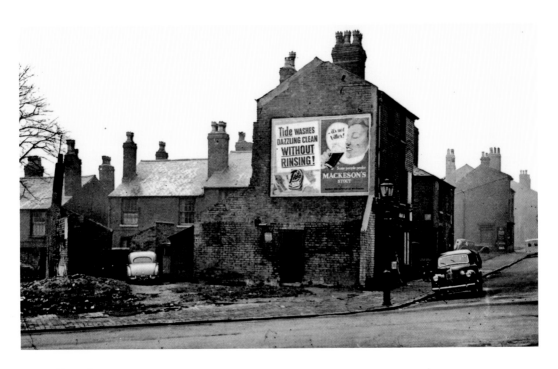

Wynn Street

Advertisements on the wall of a shop brightens up the drab appearance of this old neighbourhood. This shop was in Great Colmore Street on the corner of Wynn Street which was once located between Spring Street and Great Colmore Street with Grant Street running through the middle. Recent rearrangement of the road system has joined Grant Street with Wynn Street where both streets currently lead off Great Colmore Street the road at the bottom of the 2010 photograph.

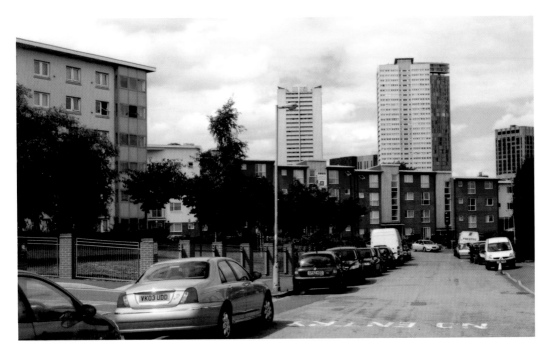

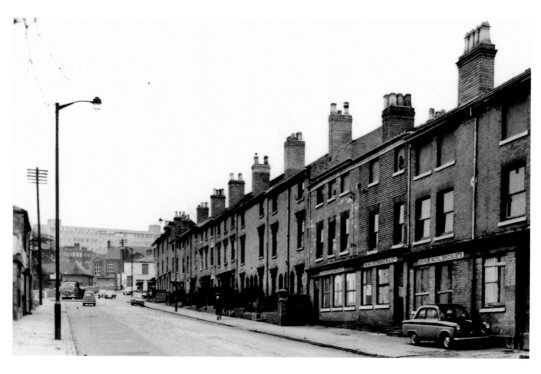

Great Colmore Street

Great Colmore Street in 1964 began at Islington Row and finished at Bristol Street. In 2010 Mason Way was part of the rearranged road system where Great Colmore Street now starts and from where the 2010 photograph was taken.

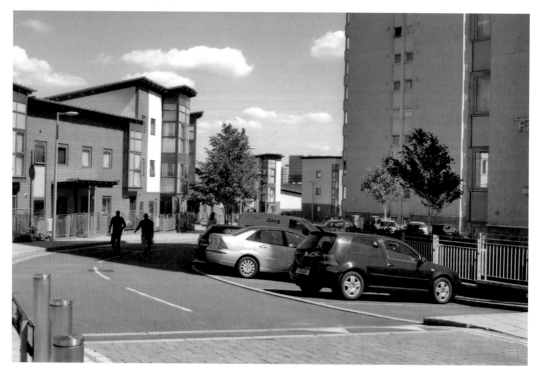

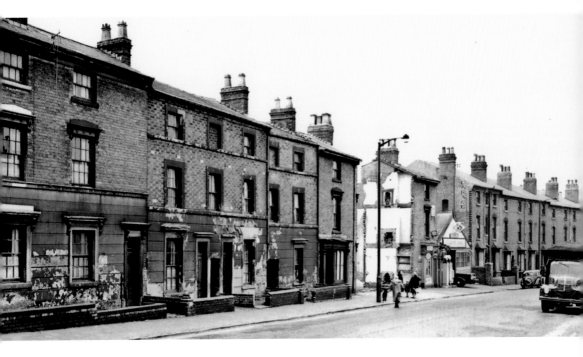

New Hotel
Functional but ageing housing existed along Great Colmore Street in the 1960s but by 2010 this had given way to a new hotel on one side and various types of modern housing on both sides that also contains trees planted along this shortened street.

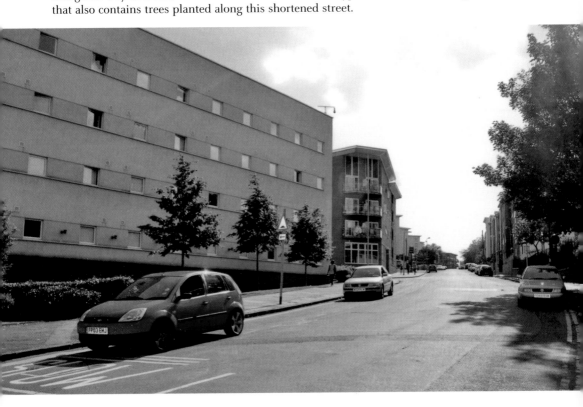

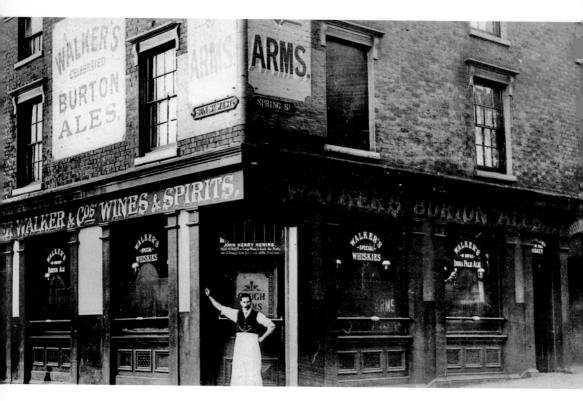

Spring Street

John Henry Hewins the licensee is probably the gentleman posing outside The Gough Arms on the corner of Sun Street West and Spring Street. Just down the road from the public house but in another era is the McDonald's burger restaurant that was built on the old Bristol Cinema site on the corner of Sun Street and Bristol Street.

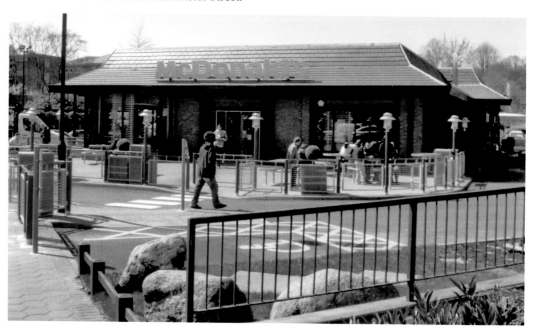

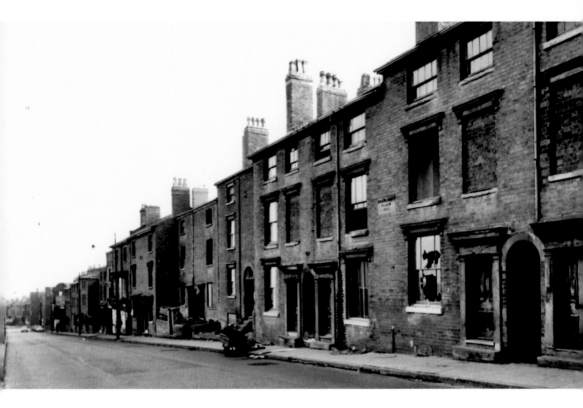

Lee Bank Road and Middleway
All the houses on either side of Lee Bank Road were swept away in the redevelopment that took place in the 1960s. Three lanes on either side of a dual carriageway have replaced the single road that ran from Bristol Street to Islington Row and on towards Five Ways and Ladywood that is now called Lee Bank Middleway.

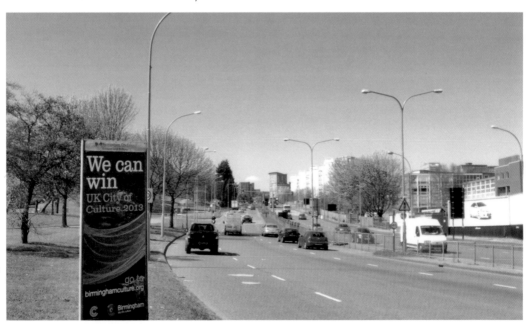

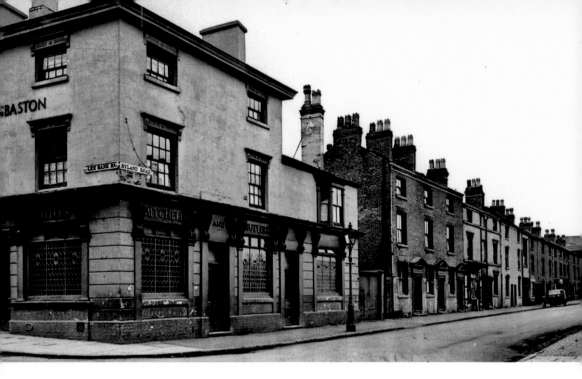

Ryland Road

The Edgbaston public house once stood on the corner of Ryland Road and Lee Bank Road a reminder this location was once part of Edgbaston. The merger of the Benmore, Five Ways, the Sentinels, Woodview and Lee Bank estates created Attwood Green. The 2010 photograph shows how Attwood Green is developing on one side of Lee Bank Middleway whereas on the old Woodview Estate side it has only been landscaped.

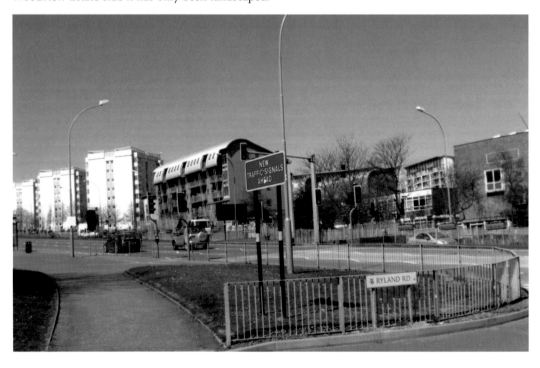

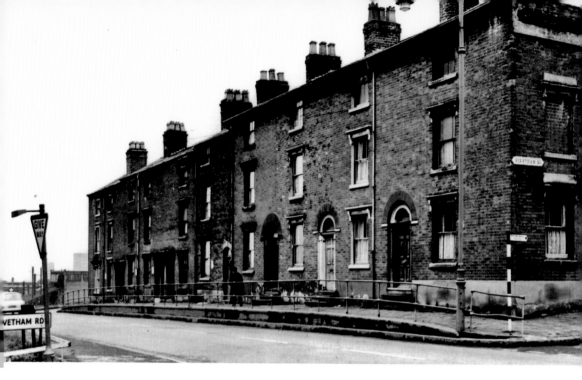

Redeveloped Twice

Elvetham Road North is located on the other side of Lee Bank Middleway from the main part that runs down to Pakenham Road as Elvetham Road. Two phases of redevelopment can be seen in the two photographs. Following the removal of the old back-to-back houses like those in the early photograph high-rise blocks of flats and maisonettes were built. The 2010 photograph shows two high-rise blocks that have not been demolished in the current redevelopment that has created Park Central out of the old Lee Bank district.

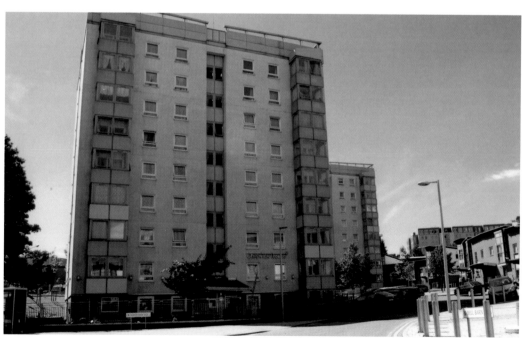

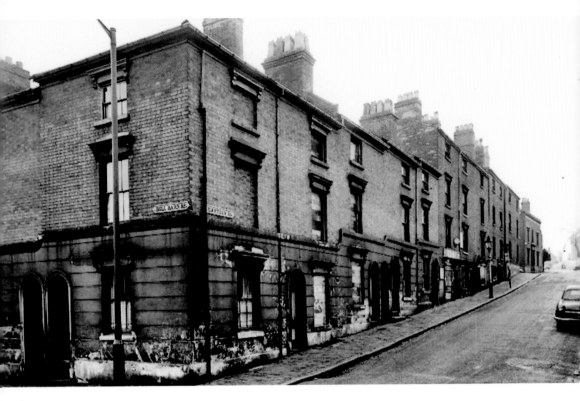

Elvetham Road North
Elvetham Road in the 1960s and how it looks in 2010 with North added to its name viewed from Bell Barn Road towards Lee Bank Middleway.

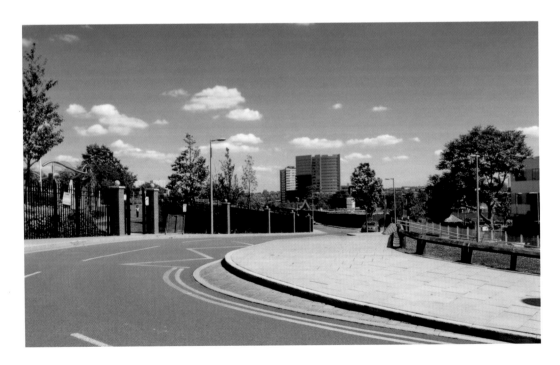

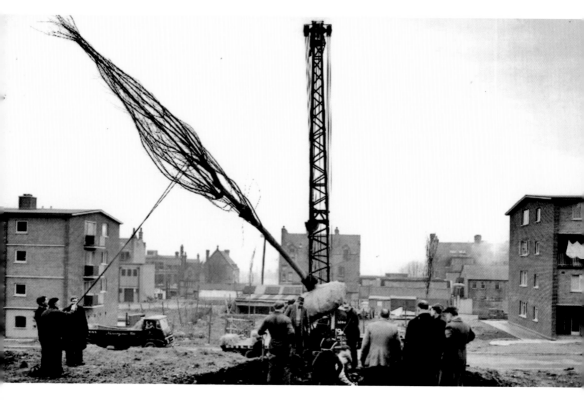

Bell Barn Road

More trees are being added along Bell Barn Road during the landscaping that followed the re-building of Lee Bank in the 1960/70s. Today all this has all been removed to make way for the modern housing that now can be seen along Bell Barn Road.

Alfred Knight Way

Sergeant Alfred Knight was born in Ladywood in 1888 he won a Victoria Cross for his gallant action at Ypres on 20 September 1917. On 9 November 2006 a road that skirts West Park, Park Central, Attwood Green was named 'Alfred Knight Way' after the local hero. The new road is located towards the Bath Row end of Bell Barn Road.

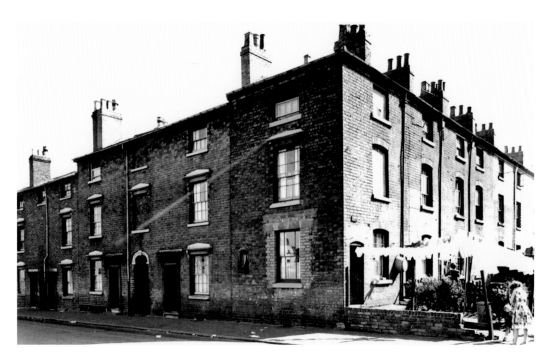

Latimer Street

Latimer Street once ran from Great Colmore Street to Piggot Street part of the Cregoe Street crossroads. The end block of houses with gardens in Latimer Street with washing blowing on the line and the tin bath on the outside wall was part of the overcrowded conditions that existed in 1960s. Having a garden of your own, of any size, to hang your washing out was a rare occurrence in Lee Bank and most families had to share the courtyard facilities provided. The contrast between then and now in the area where Latimer Street once stood is outstanding.

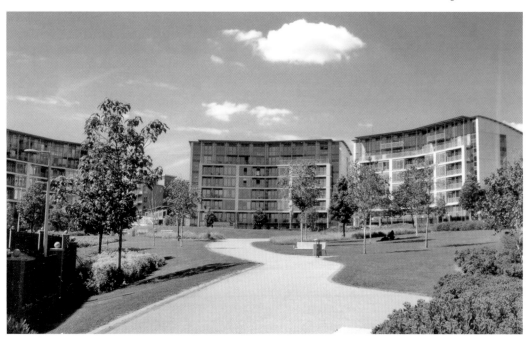

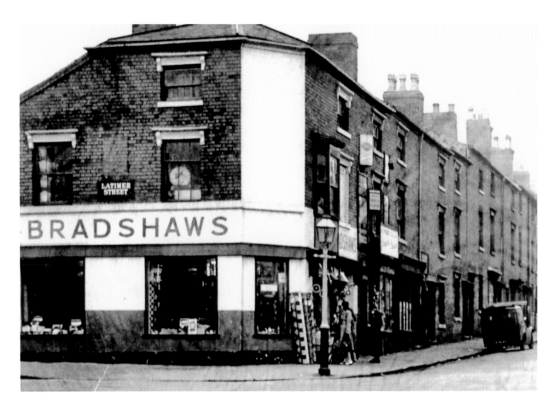

West Park

Latimer, Cregoe and Irving Streets contained a shopping area that once stood where West Park has been created on land that also housed hundreds of terrace back-to-back type properties with many more families living in houses behind them. By 1960 this type of property where everything and everybody existed in a confined space was deemed not fit for purpose. By 2010 this situation has changed spectacularly with views overlooking parkland from the modern living, social and private, housing that occupies this area now.

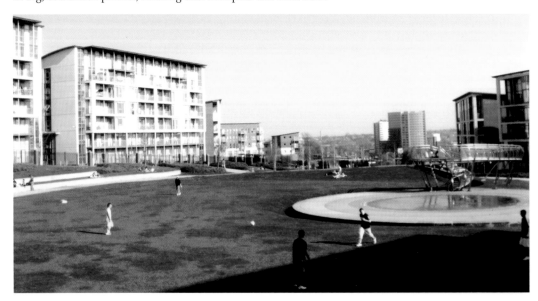

Irving Street

Neighbours out shopping find time to stop and talk on the corner of Irving Street and Cregoe Street opposite Bradshaws store where the housewife could obtain most domestic items in the 1960s. Fifty years on the old streets and shops have disappeared and a car-less expanse of green open space with walkways has been provided between the living accommodations. Not forgetting the past an aptly named Bradshaw Close forms part of this modern community.

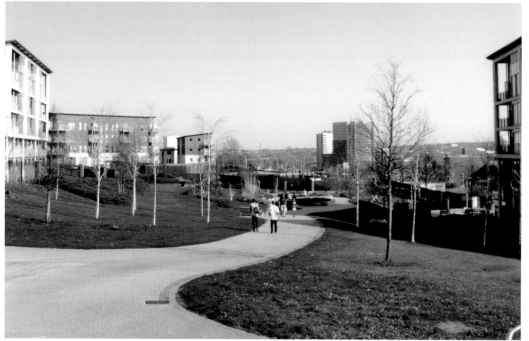

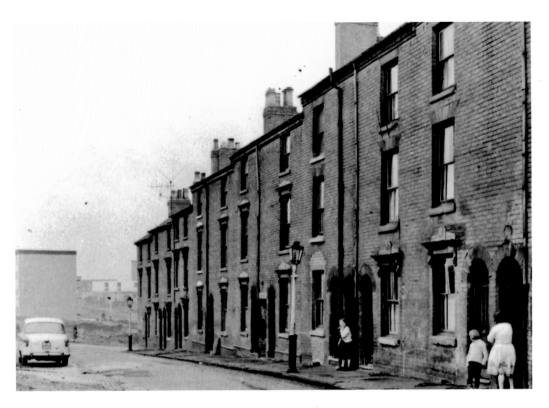

Owen Street – Longleat Avenue
Owen Street in the 1960s is almost ready for its turn to be demolished overlooking the newly built maisonettes at the end of the street. The lady standing at the top of the entry talking to her neighbour must have wondered where and when her family would eventually be re-housed. Today Owen Street no longer exists, and Longleat Avenue in the 2010 photograph has taken its place.

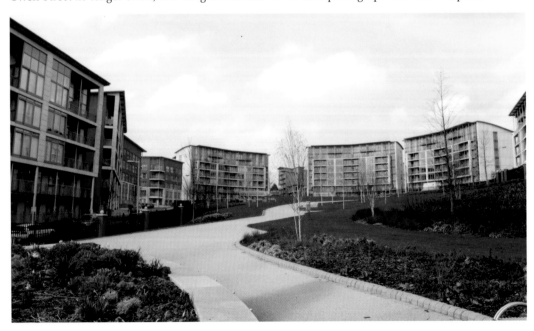

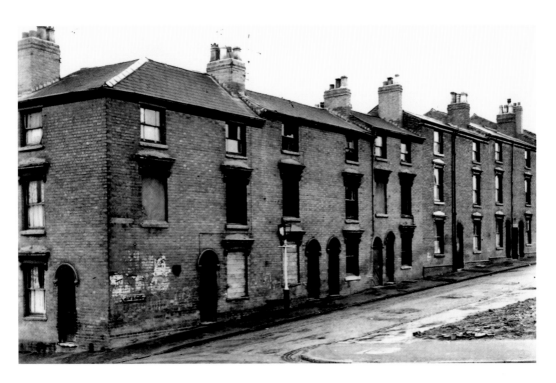

West Park – Owen Street

This scene in 1964 of desolation ascending the hill towards Wheeleys Lane has been caused by the removal of families from their homes in Owen Street to allow their old houses to be prepared for demolition. Approximately from the same position at the bottom of the hill is West Park facing Longleat Avenue a much happier looking place in 2010.

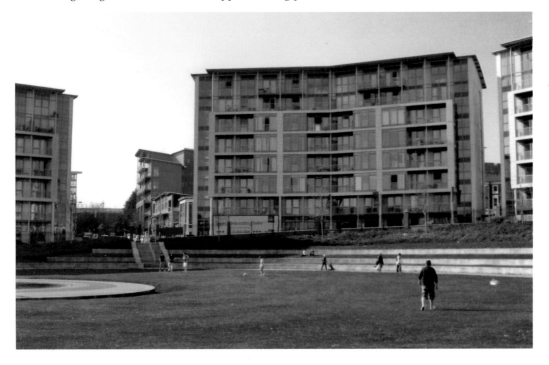

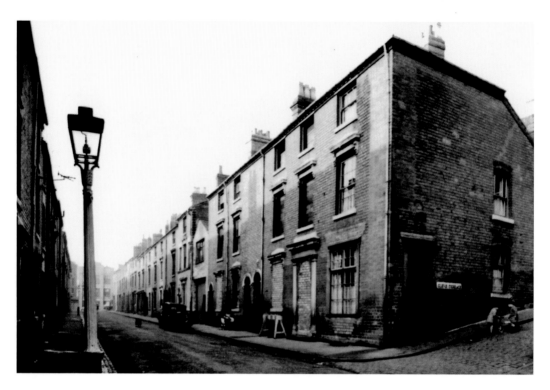

Cleve Terrace

Only one car is visible parked in Owen Street around the corner from where children are playing on the sloped, cobbled stoned Cleve Terrace. The children do not appear to be bothered about the dangers of traffic. Fifty years later no children can be seen playing only cars parked on the tree-lined pavements in a road now called Longleat Avenue.

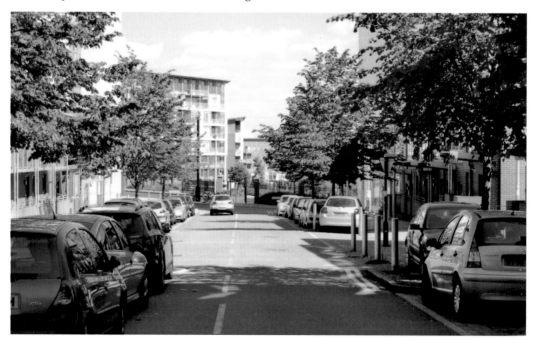

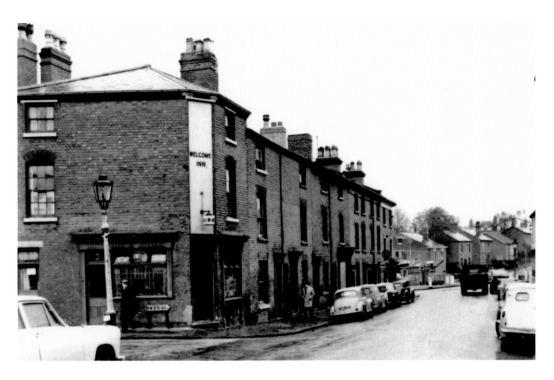

Welcome Inn

The Welcome Inn stood on one corner of Wheeleys Lane and Owen Street before its customers moved away and their homes were demolished. Today this part of Wheeleys Lane between Bath Row and Lee Bank Middleway contains a mixture of offices and modern flats.

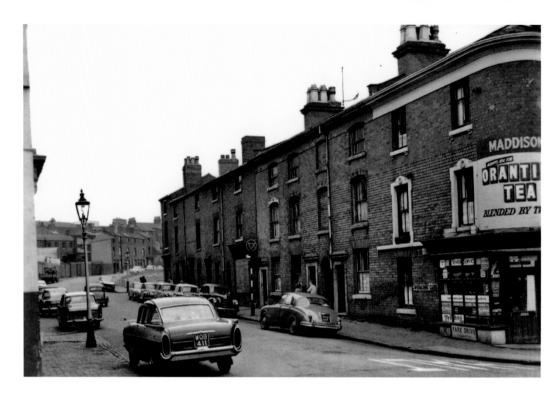

Wheeleys Lane

A corner shop was to be found along most streets and roads in working class areas. They provided, on a daily basis, the provisions that sustained the family's needs often purchased on credit. The shop in the 1964 photograph was on the Wheeleys Lane corner with Great Colmore Street at the far end but today's rearranged road system prevents this arrangement. The 2010 photograph is of Wheeleys Lane facing Bath Row.

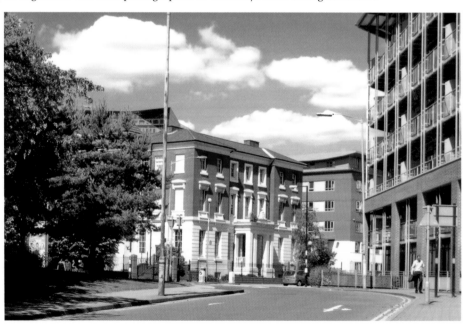

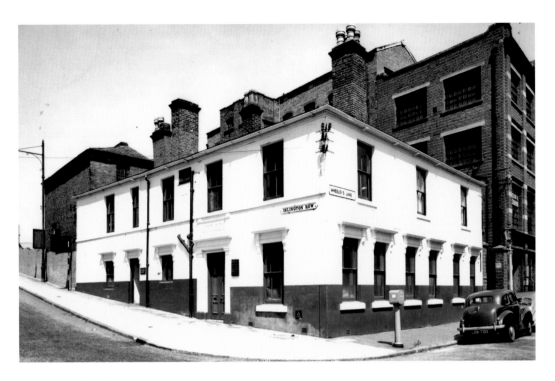

Wheeleys Lane

Before the days of mass telecommunications the ability to call the fire brigade required finding and activating an external Fire Alarm point. On certain prominent corners like Wheeleys Lane and Islington Row in the 1957 photograph a Fire Alarm point painted red was sited. White fronted offices could also be found on this corner with a factory alongside but by 2010 they have all been replaced.

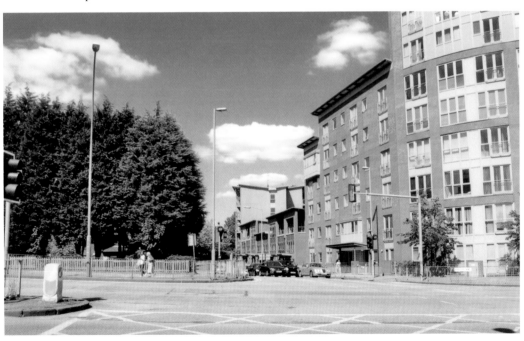

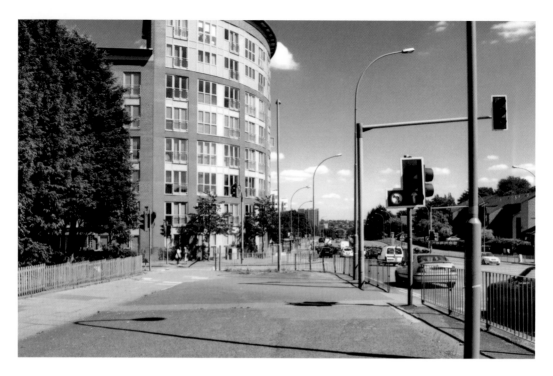

Islington Row

Islington Row from Five Ways to the Bristol Road became Lee Bank Road at the Wheeleys Lane crossroads. One time this route had houses and shops on either side of the road now the motorist travels, the whole length, along a three-lane dual carriageway that has pedestrian safety barriers installed.

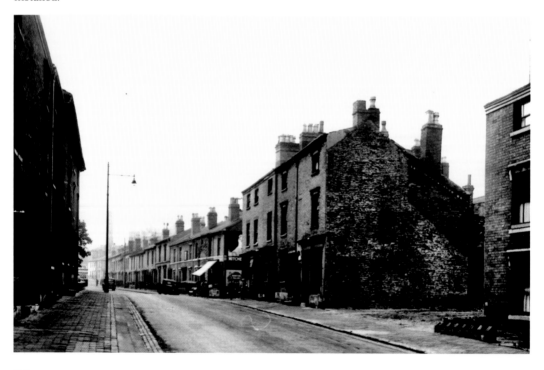

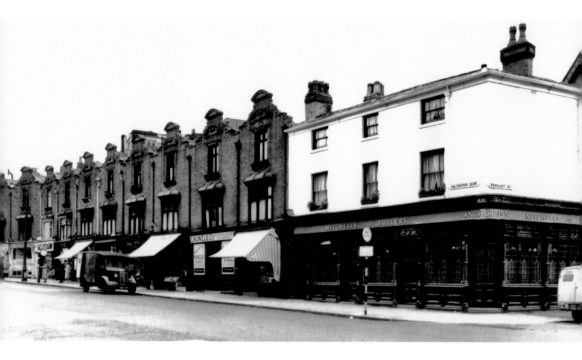

Five Ways Shopping Centre

All the shops along Islington Row from Five Ways to the Anchor Inn public House on the corner of Tennant Street were demolished in the 1960s to make way for the Five Ways Shopping Centre. In the 2010 photograph behind the shopping centre is Auchinleck House and behind that is Metropolitan House a building with a large number one on the outside wall near the roof.

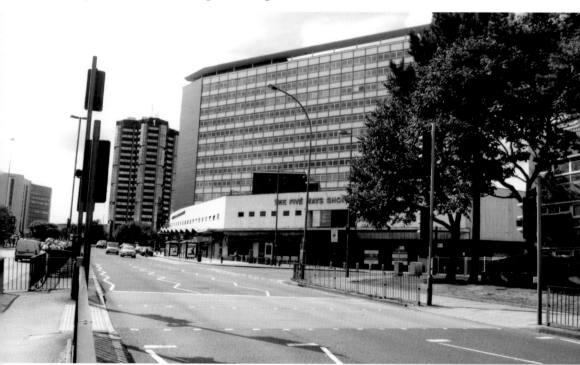

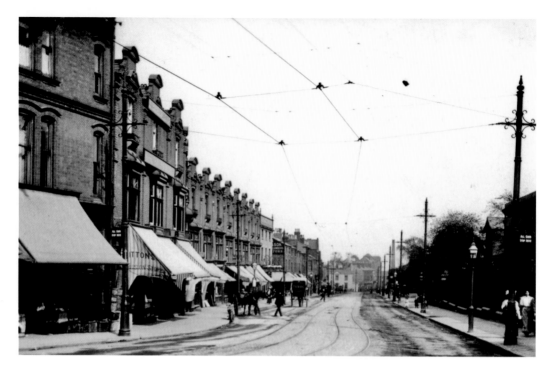

Islington Row

Two views of Islington Row from Five Ways almost one hundred years apart. Horse-drawn carriages and tramlines occupy the single road system with a row of Victorian shops on the left. By 2010 the shops have gone and trees set in a grass verge alongside a dual carriageway with flower boxes attached to the centre barriers greet the motorist travelling from Five Ways.

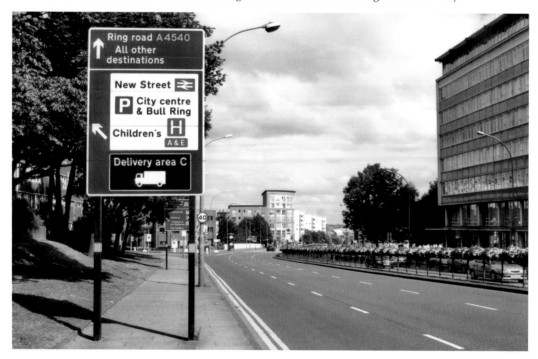

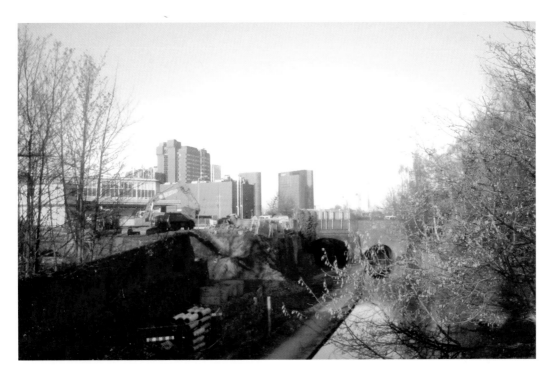

Canal Views

From a bridge on Islington Row overlooking the Worcester and Birmingham Canal two photographs were taken five years apart towards Birmingham city centre. One in 2005 and the other in 2010 illustrate the changing face of the area. Large office blocks now mask the previous buildings but both show the BT Tower in Lionel Street in the distance.

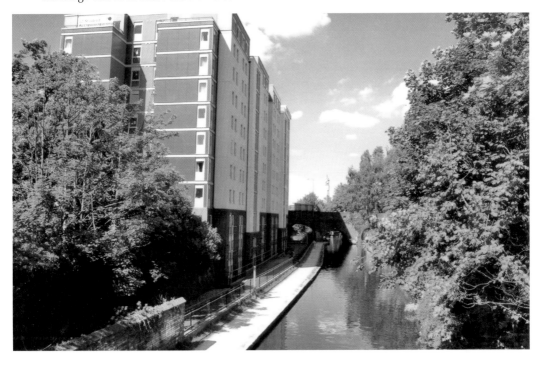

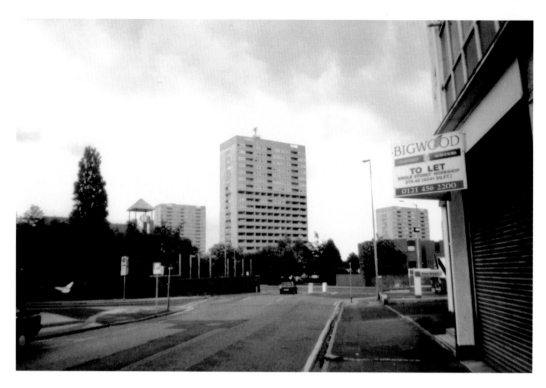

Bishopsgate Street

Bishopsgate Street towards Bath Row with Communication Row on the left in the year 2000 illustrates three high-rise tower blocks built during the 1960s in the Lee Bank area. No tower blocks are visible in the same scene taken in 2010 by then the Attwood Green redevelopment had started removing some of the tower blocks.

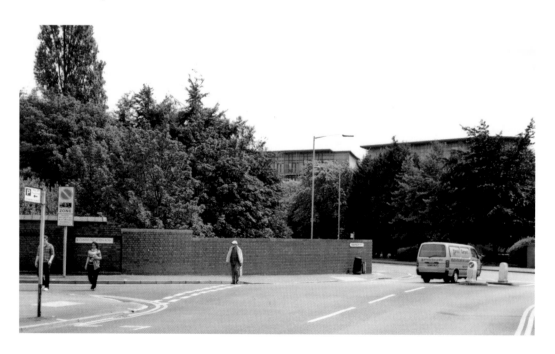

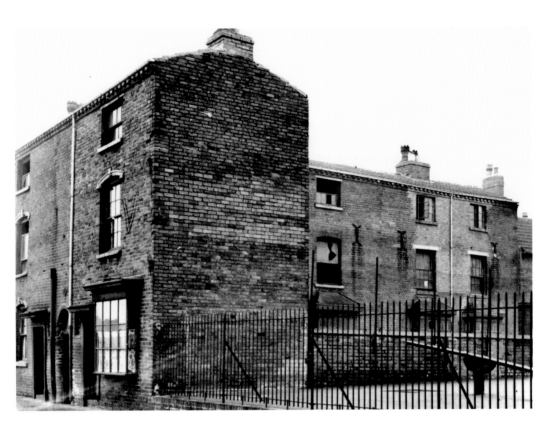

Communication Row

Back-to-back houses and a rare play area in Communication Row located off Bath Row near Bishopsgate Street served the local community until they were demolished in the 1960s. An unused piece of land that has been fenced off now occupies this part of Communication Row.

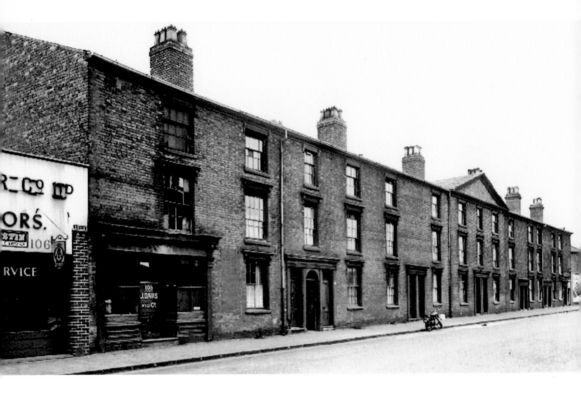

Bath Row

Bath Row towards Wheeleys Lane in 1953 had working class terraced housing along both sides of the road with some light industrial premises between. Now multi level commercial and residential units have taken their place.

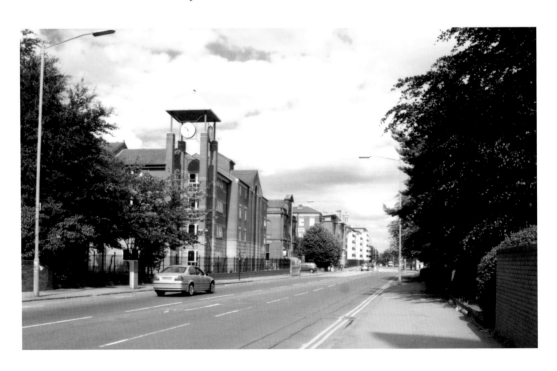

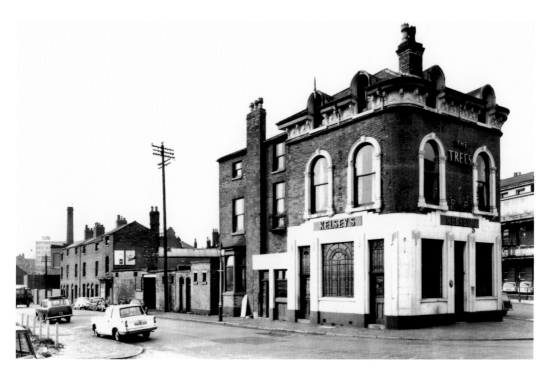

The Trees

In 1965 on the Wheeleys Lane and Bath Row corner stood The Trees public house a grand building where a large number of pints have been pulled over the years since it first opened. The pub together with the local community it served can no longer be found frequenting this corner since six-storey apartment blocks were built replacing them.

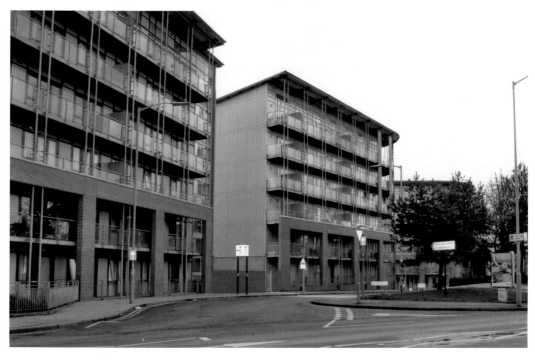

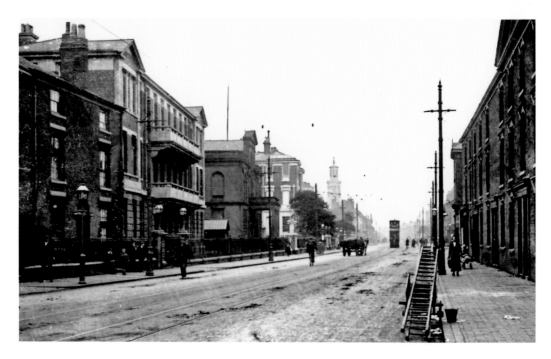

Bath Row

Two views of Bath Row towards Holloway Head many years apart exemplifies how this thoroughfare that was once the main route out of Birmingham to Bristol and the West Country has changed. Pointing the way to Park Central is a sign on a lamppost directing people to one of the new parts being created in this area through the regeneration of the previous Lee Bank district now called Attwood Green.

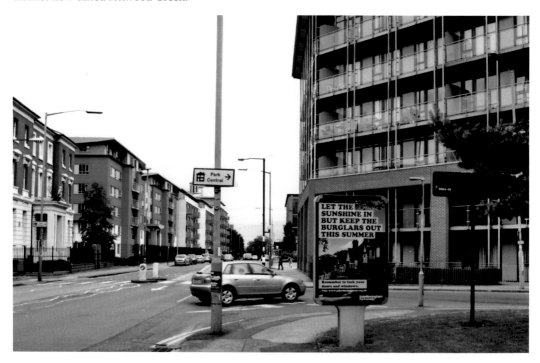

Park Central

St Thomas Church tower in Bath Row is probably the oldest structure in the district, ironically Birmingham's latest addition, the "Cube" can be seen behind. Having survived the extensive changes the Lee Bank district of Birmingham has experienced the church tower now overlooks the rejuvenated Cregoe Street in Park Central Attwood Green the name that replaced Lee Bank.

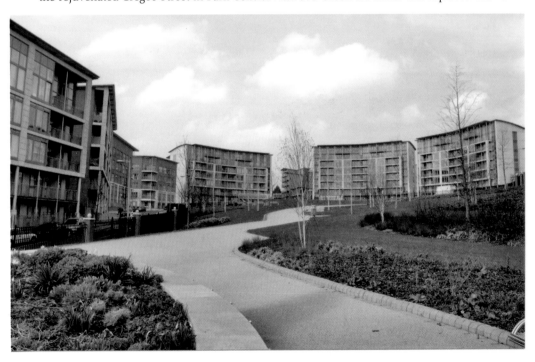

Acknowledgements

The authors of *Lee Bank to Attwood Green Through Time* Ted Rudge www.winsongreentobrookfields.co.uk and Keith Clenton (volunteer at the Carl Chinn archive) acknowledge the completion of this book has been made possible by the generosity in time and materials from many people and if any are missed out in this acknowledgment we apologise.

Thank you to the following people, web sites and companies who have provided help with this project.

Professor Carl Chinn; http://lives.bgfl.org/carlchinn/ for allowing us to use photographs from the "Carl Chinn Archive" and for writing the foreword to this book. To the volunteers at the Carl Chinn archive, their kind help and support given was appreciated.

Sally Earl www.core-marketing.co.uk for advice about the area, encouragement with the project and the provision of certain photographs.

Optima Community Association www.optima.org.uk is thanked for their support.

Mac Joseph www.oldladywood.co.uk is thanked for providing photographs from his private collection.

And to the people that contributed from the Ted Rudge website www.winsongreentobrookfields.co.uk.

For proof reading the text and providing encouragement with the project we are indebted to Ted's wife Maureen.

Finally we would also like to thank Amberley Publishing for given us the opportunity to produce this local history book describing some of the changes, mainly environmental, displayed in *Lee Bank to Attwood Green Through Time* and to everyone who reads the book we trust it rekindles memories the way it was or still is for you.

Ted Rudge MA and Keith Clenton

* * * * * *

Other Birmingham *Through Time* Amberley Publications

Winson Green to Brookfields Through Time by Ted Rudge
In and Around Ladywood Through Time by Ted Rudge
In and Around Aston Through Time by Ted Rudge and John Houghton
Birmingham Up Town Through Time by Ted Rudge, Mac Joseph & John Houghton
Small Heath & Sparkbrook Through Time by Ted Rudge & Keith Clenton
Hockley Through Time by Ted Rudge and John Houghton